HIDDEN
HISTORY
of
FLINT

Gary Flinn

THE
History
PRESS

Published by The History Press
Charleston, SC
www.historypress.net

Front cover: An early 1920s photo of downtown Flint. *Courtesy of the Library of Congress.*
Back cover, top: A 1950s photo of the future location of the University of Michigan–Flint
campus. *Gary Flinn; inset*: Lloyd Copeman, prolific Flint inventor. *Courtesy of Kent Copeman.*

First published 2017

Manufactured in the United States

ISBN 9781625858412

Library of Congress Control Number: 2017934925

3 9082 13252 8418

This book is dedicated to the people of Flint
who are enduring the Flint water crisis.

Contents

Preface and Updates

This is the second book I have written with stories from the Vehicle City. History is a continuing process and because of that, there have been a few changes regarding people, places and institutions since my first book, *Remembering Flint Michigan: Stories from the Vehicle City*, was published in 2010. With this introduction, I will provide updates from my previous book.

BANKS FROM FLINT'S PAST

In 2013, Citizens Republic Bancorp, parent company of Citizens Bank, was sold and absorbed into Akron, Ohio–based FirstMerit Bank. FirstMerit was, in turn, sold in August 2016 to Columbus, Ohio–based Huntington Bancshares, parent company of the Huntington National Bank, which entered the Flint marketplace when it bought the local operations of Bank of America in 2014. Huntington's Flint-area bank branches went by several names over the years, and their story can be found in chapter 24.

WHEN MASS TRANSIT USED ELECTRICITY

Since that chapter was written, the Mass Transportation Authority (MTA) began building up a fleet of diesel/electric hybrid buses in 2013, beginning with fifteen buses with additional buses added to replace older diesel buses.

The MTA also has a fleet of buses that run on natural gas and a fleet of Your Ride vehicles, which run on propane, along with a couple buses that run on hydrogen.

REMEMBERING FLINT CENTRAL HIGH SCHOOL

While the school is still closed, there is talk, if money becomes available, to build a new middle/high school on the site of Flint Central and the adjacent old Whittier Middle School to eventually become Flint's only high school. In what became the first sign that my first book was becoming outdated, in October 2010, when the book was first being published, the owners of WFBE radio vacated its former studio location in the lower level of Central. I had mentioned in my previous book that WFBE's owners had built new transmitting facilities in Burton on Bristol Road near Dort Highway at the co-owned WTRX transmitter location, utilizing WTRX's tall north tower mounting WFBE's transmitting antenna on the WTRX tower. After the new transmitting facilities became operational, the owners not only removed the transmitting equipment, they had also taken down the old WFBE tower, cut it up and put the pieces in a large dumpster. They had neglected to plug up the holes where the transmission line and electrical conduit passed through, making the old transmitter room into a possible habitat for critters. In 2011, WFBE/WTRX's parent company was sold to Cumulus Media, which already owned four Flint radio stations. As a condition of the sale, Cumulus had to dispose of WRSR "The Fox" 103.9 FM, which moved from Cumulus Flint's studio cluster location on Taylor Drive in Mundy Township to the former WFBE/WTRX studio location on Miller Road across from Genesee Valley after WFBE and WTRX were moved to Taylor Drive. A trustee operated WRSR until it was sold to Krol Communications in 2012.

A TASTY PART OF FLINT HISTORY

In 2010, the Thomas family sold the Halo Burger chain to local Subway franchisee Dortch Enterprises. In 2016, the chain was sold again to a Michigan group, forming Halo Country LLC as the parent company to Halo Burger, which changed the Halo Burger logo.

GOODBYE, WFDF

In 2014, Radio Disney changed its focus and sold nearly all its terrestrial radio stations, including WFDF. WFDF was sold to the Word Network led by Kevin Adell, which took over the station in 2015, still based in the Detroit suburb of Southfield. Under Adell, WFDF initially aired a religious format before switching over to an urban talk format in 2016 and started calling itself the 910 AM Superstation.

THE CAPITOL THEATRE

A Downtown Flint Jewel

While under private ownership, the Farah family was able to do a partial restoration of the Capitol Theatre's lobby area with work underway to restore more of the theater building. But under private ownership, money was not available for a full restoration. So the Farah family sold the Capitol Theatre in 2015 to a nonprofit unit of Uptown Reinvestment Corp. The new owner is the Friends of the Capitol Theatre, which immediately announced restoration plans originally estimated to cost $21 million. Restoration work began in 2016. The group is partnering with the Flint Cultural Center Corporation and the Whiting Auditorium, which will manage the Capitol Theatre, including programming and marketing, with a planned opening date in late 2017. The marquee and blade sign were replicated by Signs by Crannie with aluminum using LED light bulbs, utilizing electronic attraction boards with the center board still using hanging letters. The plain-looking third-story addition was torn down, the offices and storefronts rehabilitated and the theater restored inside and out to the way it looked in 1928, with state-of-the-art stage equipment along with a digital projector and a new screen to show movies. Parts of the arcade are incorporated into the lobby with first-floor restrooms, an additional elevator and a relocated refreshment stand. The theater, meeting modern building codes, has a reduced seating capacity with 1,500 brand new retro style seats. Plans are to donate the old signs to the Sloan Museum.

THE HISTORY OF FLINT'S ALTERNATIVE NEWSPAPERS

The alternative publication *Broadside* invited this writer to contribute local history articles that would eventually be included in this book. After twenty-four issues were published, *Broadside* suspended publication in 2014. The reason cited was that the people involved had become too busy with other activities and projects.

FLINT'S DRIVE-IN THEATERS

The Flint area's last remaining drive-in theater, the US 23 Drive-in Theatre, was equipped with digital projectors in 2013 and continues to draw moviegoers each summer. The Back to the Bricks annual August series of events is kicked off each year by Bricks Flicks, which features classic cars—often overflowing the drive-in—a DJ and a free automotive-themed classic movie showing at dusk. Meanwhile, all structures except the two screen towers and attraction boards were torn down in 2012 at the vacant Miracle Twin Drive-in Theatre in Burton. Vegetation is growing on cracks in the asphalt field where the speaker poles still stand. The property at this writing is listed for sale with the asking price of $1.6 million.

FLINT'S CARTOON MASCOTS

The WFBE bee mascot was retired in 2014 when the station changed its branding from B95 to Nash FM. The Halo Burger cow, which was retired after Dortch Enterprises took over, was brought back in 2016 by new owner Halo Country after it was given a makeover.

EARLY TV IN FLINT, OR THE LACK OF IT

The board of trustees of Central Michigan University, which operated Flint's PBS station WCMZ-TV channel 28, which rebroadcasts WCMU-TV in Mt. Pleasant, voted to sell the station's broadcast spectrum for $14 million. CMU bought what was then WFUM-TV from the University of Michigan

for $1 million in 2009. The reason stated was that nearly all of channel 28's viewers can pick up other PBS stations, such as Delta College's WDCQ-TV channel 19 licensed to Bad Axe and Michigan State University's WKAR-TV channel 23 in East Lansing. CMU's other TV and radio stations would remain on the air. It did ask cable and satellite providers to keep CMU Public TV on their channel lineups. Channel 28 would go off the air by summer, allowing mobile and wireless devices to use the bandwidth.

THE CITIZENS BANK WEATHER BALL

A Very Useful Landmark

After FirstMerit Bank took over Citizens Bank, the neon *CB* letters were taken down and the letters *FM* along with its diamond-shaped logo were put up below the weather ball. The Huntington National Bank, which bought FirstMerit in August 2016, has stated it will keep the weather ball. There have been calls for Huntington to install the new letters in the same style as the scrapped *CB* letters. How the weather ball would look after Huntington converted the FirstMerit branches to Huntington branches on February 21, 2017, was not revealed by the deadline for this book.

THE DORT MALL

Magnet for Collectible Buffs

After mall owner Bob Perani died in 2012, the Perani family sold off most of the collectibles inside and outside the Dort Mall, where Perani's Hockey World is still based.

A VISIT TO A SIGN COMPANY'S BONEYARD

Signs by Crannie's business has grown so big that it moved to a larger location in 2015 on Market Place off Bristol Road near Bishop Airport. The business sold off the old signs in the old boneyard on Commerce Drive in Flushing in 2016.

Acknowledgements

S everal visits to the Flint Public Library were needed to research the chapters in this book, and I thank Michael Madden for his assistance. I also thank my editors Krista Slavicek and Abigail Fleming, as they gave me helpful advice. Thanks also to the Genesee County Historical Society. Thanks also go to the contributors to *Broadside* led by Bob and Melodie Mabbitt, who encouraged me to keep writing articles. Many of the chapters in this book are based on articles originally published in *Broadside*. Thanks also go to people specifically mentioned at the end of chapters who assisted me on certain chapters. Thanks also go to the people who posted on the Remembering Flint, Michigan Facebook page (since renamed the Hidden History of Flint Facebook page) with their tips and suggestions. Special thanks to Ivonne Raniszewski for her encouragement for me to complete my second book.

1

Flint

An Indian Reservation?

The 1819 Saginaw Cession and Treaty ceded a large swath of central Michigan to the United States of America. The land was originally occupied by members of the Chippewa, Ottawa, Potawatami and Wyandotte Nations. As a provision of the treaty, eleven tracts of land located along the Flint River where present-day Flint is were reserved for the following people: Nowokeshik, Metawanene, Mokitchenoqua, Petabonaqua, Messawwakut, Checbalk, Kitchegeequa, Sagaosoqua, Annoketoqua and Tawcumegoqua, who each got 640 acres of land located at or near "the grand traverse of the Flint river, in such manner as the President of the United States may direct," according to that treaty.

One man who had a major role in the treaty was the founder of Flint, Jacob Smith, a native of Quebec. He was the first white settler to set up shop in the area. He lived alone in Flint, while his wife, Mary, and children lived in Detroit. Sources dispute Mary's ethnic heritage. Some say she was of Scottish ancestry; others say she was a Chippewa. Jacob built his cabin along the Flint River around 1811. Flint was connected to Detroit by the Saginaw Trail, from which Saginaw Street, Dixie Highway and Woodward Avenue developed. He was adopted by the Chippewa Nation and given the name *Wahbesins*, which means "Young Swan." He established a fur-trading business in present-day Flint with the natives. After his wife died, he moved permanently to his Flint River cabin in 1819. He died in 1825 and was buried by Baptiste Cochios, a friendly mixed-blood trader, and "Jack," an Indian boy whom Jacob adopted, beside his cabin near where First Avenue

Drawing depicting Jacob Smith's family. No portrait of Jacob Smith is known to exist. *From the Flint Board of Education's textbook* Tales of Early Flint.

and Lyon Street is today. He was later reburied at Glenwood Cemetery. After the death of Smith's friend Chief Neome in 1827, several members of his band dispersed to other parts of Genesee County.

Looking at the map of the eleven tracts of land along the Flint River, there is more to it. Five of the six lots north of the Flint River were actually assigned to Jacob Smith's children using their Indian names. Some sources

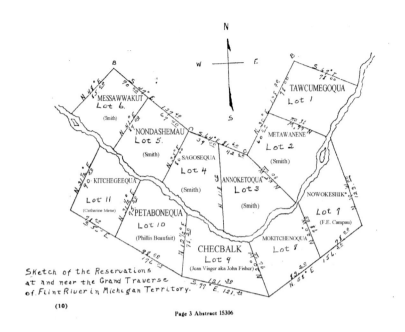

Land reserved for Jacob Smith's children just north of Flint River in Carriage Town. *Gary Flinn.*

say that Mokitchenoqua, who was given Lot No. 8, was a Chippewa mixed-blood daughter of Smith's. For nearly forty years, there was litigation over ownership of much of the Smith property, which retarded development north of the Flint River. The native population was decimated by outbreaks of cholera in 1834 and smallpox in 1837—diseases introduced by the white man.

In 1836, the federal government established a land office for the sale of public land in the Flint River settlement, which was incorporated in 1855 as the City of Flint. For this chapter, I will concentrate on two of the eleven tracts in the Flint River Reservation. They are Lot No. 2, which is north of the Flint River, and Lot No. 7, which is south of the Flint River. Both of these lots include the immediate downtown Flint area.

Lot No. 7 was assigned to Nowokeshik, whose European name was François Edouard Campau. He was a mixed-blood employee of Jacob Smith. He sold his land in 1830 to the first permanent white settler who brought his family over, John Todd, for $800. It was determined that Campau did not have plans to permanently settle on his land and had planned on selling the land if the price was right. John Todd and his wife,

Polly, established a tavern where downtown Flint is today. In 1831, Flint's first wedding took place in Todd's Tavern.

Lot No. 2 was assigned to Metawanene, whose European name was Albert J. Smith. Albert was born in Detroit in 1811, Jacob Smith's only son. A patent for this lot was signed by President Andrew Jackson on July 2, 1836, reserving this lot to Albert Smith. Albert Smith, who was still living in Detroit at the time, sold a quarter of Lot No. 2 to his brother-in-law Thomas B.W. Stockton, on October 10, 1836, for $25,000. The remaining three-fourths of the lot was sold to another brother-in-law, Chauncey S. Payne of Willoughby, Ohio, for $25,000 on October 25, 1836. Payne was married to Louisa Smith Payne. Stockton and Payne jointly put out a $5,000 mortgage at the Farmers and Mechanics Bank of Michigan in 1838. That bank assigned the mortgage to Asa T. Crosby in 1847 and was reassigned by Crosby to Levi Brown of Brooklyn, New York, for $4,000. In 1851, Brown assigned the mortgage to Henry A. Brown, also of Brooklyn, in trust. The mortgage was released back to Payne and Stockton in 1853 as paid in full.

In 1837, Payne platted the village of Grand Traverse (later known as Flint) on Lot 2, and a map was drawn. The map stated that all regular lots represented on this map were intended to be 66 feet by 132 feet. Saginaw Street is 99 feet wide, Detroit Street (now Martin Luther King Avenue) is 80 feet wide and all other streets 60 feet wide.

In 1840, Stockton and his wife, Maria G. Smith Stockton, sold their land in 1840 to Payne.

A quitclaim deed was issued in 1845 for consideration of "$100 and divers" from Metawanene, alias William Smith, to Chauncey S. Payne for section 2 of the 11 sectors.

When Jacob Smith died in 1825 at age forty-five (his tombstone gives the wrong birth year), his legal affairs were incomplete. The other four lots reserved for his children were No. 6, intended for Messawwakut (Harriet M. Smith), No. 5 for Nondashemau (a.k.a. Maria Smith Stockton), #4 for Sagaosoqua (Caroline Smith) and No. 3 for Annoketoqua (Louisa Smith Payne). The five patents for Lots 2 through 6 were issued on June 2, 1836. Around that time, the aforementioned Jack, who helped to bury Jacob Smith, claimed to be also named Metawanene and claimed ownership of Lot No. 2.

In March 1841, Jack deeded this tract to Gardner D. Williams, of Saginaw, who, in June 1845, conveyed a portion of the lot to Daniel D. Dewey of Genesee. They filed a lawsuit to determine who the real Metawanene was and who was legally entitled to the lands. The case, with Gardner L. Williams, Daniel D. Dewey and Metawanene as plaintiffs and Chauncey S. Payne as

defendant, was tried in Genesee County Circuit Court in March 1856. The jury in the trial decided, "Chauncey S. Payne is not guilty of unlawfully withholding from said plaintiffs the premises described in manner and form as the said plaintiffs hath, in their Declaration in this cause, alleged." I believe Jack is the William Smith identified in the above quitclaim deed from 1845. So the real Metawanene was Albert Smith, according to the jury. Albert Smith died in New York City in 1883; Chauncey Payne died in Flint in 1877; Louisa Payne died in 1888; Colonel Thomas B.W. Stockton died in 1890; and Maria Stockton died in 1898. They are buried with Jacob Smith at Glenwood Cemetery.

So while "Smith's Reservations" were supposed to be reserved for the native peoples, the intended recipients' crossbreeding with white settlers, property sales to settlers and Jacob Smith's family (whether or not they had Indian blood in them) receiving lots prevented the reservation from become a true Indian reservation. Jacob Smith saw potential in the land along the Flint River when he negotiated for that land in the 1819 Saginaw Treaty. While the native peoples were generally friendly toward the settlers, there were some Indians who were hostile to the white man. One was an old Canadian chief, Kiskanwo. During the break in the treaty negotiations, Smith and his allies were able to get Chief Kiskanwo dead drunk before treaty negotiations resumed. That was one way Jacob Smith was able to get what he wanted in the treaty. Even though the Flint reservation did not become a true reservation like the Chippewa reservation near Mount Pleasant—where the Soaring Eagle Casino is—I'm wondering if the fact that Flint did develop from an Indian reservation would allow for an Indian-run casino in any of the eleven lots drawn up in the 1819 treaty.

Article 4 of that treaty reads, "In consideration of the cession aforesaid, the United States agree to pay to the Chippewa nation of Indians, annually, for ever, the sum of one thousand dollars in silver, and do hereby agree that the annuities due by any former treaty to the said tribe, shall be hereafter paid in silver." Knowing that the government has a history of not fulfilling its obligations from the various treaties with the Indians over the years, I asked Anita Heard, coordinator of the Nindakenjigewinoong Research Center at the Ziibiwing Center of Anishinable Culture and Lifeways at the Saginaw Chippewa Reservation in Mount Pleasant, if the government is still making annual payments in silver. Her answer is that the government is not making any payments to anyone from any treaty with the Chippewa Nation. So the Chippewa

Nation may have a case if members want to repossess Flint. Come to think of it, considering how the city of Flint is right now, I don't think the Chippewa people would want Flint back.

If they read the restrictions on my abstract dated March 25, 1939, for my home, which is in Lot No. 10 of the original reservations, they would be shocked by the second paragraph, which reads, "The said premises shall not be sold, conveyed, leased to or in any way occupied by any person or persons not wholly of the white or Caucasian Race." That restriction was rendered unenforceable by anti-discrimination laws in the 1960s, including the Federal Fair Housing Act of 1968.

This chapter was based on research this writer did for Bob Mabbitt's article published in the June 2006 issue of the Uncommon Sense *titled "This Land Is My Land."*

2

Gary and the Technicolor Dream Capote

Recalling when you were taught early American history, you may have learned about a British trading company called the Hudson's Bay Company, which was founded on May 2, 1670 as "The Governor and Company of Adventurers in England tradeing [*sic*] Into Hudson's Bay." Michigan's coat of arms was inspired by the coat of arms of the Hudson's Bay Company.

The Hudson's Bay Company traded with the native peoples in North America in present-day Canada and the northern United States. Beaver pelts were traded for such goods as axes, ironware, copperware, knives, firearms and wool blankets. Among the wool blankets the Hudson's Bay Company traded with the natives of North America was the point blanket, which was made in England. The point blankets were available in different sizes determined by the number of short lines or "points" on each blanket. There are records that state that four-point blankets were standard issue for American militiamen during the Revolutionary War.

Besides obvious use as sleeping blankets to keep warm during the cold winter months, point blankets were also made into clothing, whether they were worn like robes or togas or sewn into coats. French fur traders made wool blankets into long hooded coats called capotes, which the native peoples also adopted. Local Chippewa chief Neome and his friend Flint founder Jacob Smith, who came to this area from Quebec, might have worn capotes. During the War of 1812, British soldiers on Mackinac Island used a supply of point blankets and made them into short coats, which are still called mackinaws.

Unless you frequently shop in Canada, you might be surprised that the Hudson's Bay Company still exists as North America's oldest retailer, with Hudson's Bay its flagship department store chain. The Hudson's Bay Company also owns the American department store chains Lord & Taylor and Saks Fifth Avenue. You might also be surprised that the Hudson's Bay point blankets, sold beginning around 1780, are still available at Hudson's Bay stores throughout Canada and are still made in England. The Hudson's Bay point blanket is also available in the United States through Woolrich, which has the exclusive license to import Hudson's Bay point blankets into the United States.

While shopping at the outlet mall in Birch Run in 2008, I looked up the list of tenants and was surprised to see that Woolrich operated an outlet store at what is now Birch Run Premium Outlets. When I first stopped there, I asked where their blankets were and was directed to the back of the store, where they offered different varieties of blankets, including army blankets from the Civil War era and new four-point Hudson's Bay blankets for full-sized beds, six-point blankets for queen-sized beds and eight-point for king-sized beds. They are available in different styles, but the most popular is the classic white blanket with four different color stripes—green, red, yellow and indigo. They also offer pillow shams and a smaller throw blanket. At that time, I could only afford the throw, which is now on my living room sofa.

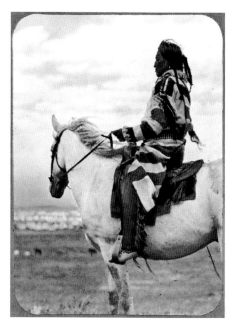

But thanks to saving enough money, I got the classic multicolor four-point blanket. Back in 2008, the Woolrich outlet store in Birch Run sold the blanket for $222, while the suggested retail price at that time was $370. Obviously, the larger six- and eight-point blankets are much more expensive. That store has since closed.

Walter McClintock's photo of William Jackson/Little Blackfeet on a white horse wearing a wool capote, circa 1900. *From the Yale Collection of Western Americana, Beinecke Rare Book and Manuscript Library.*

Just before Thanksgiving 2009, I took part in an interfaith service

at the Louhelen Baha'i School in Davison. With the Native Americans in attendance there, the service developed into a powwow. This had me thinking that I should have worn my Hudson's Bay four-point blanket like a robe. But I realized that the thick four-point blanket was too bulky and large to wear like that. So I thought about a blanket coat like the capotes worn two hundred years ago. While the Hudson's Bay Company used to make coats using point blanket material, they stopped making them in recent years. But they are still marketing coats and other products that bear the Hudson's Bay stripes.

Fortunately, I found a place on the Internet called Northwest Traders in Enon, Ohio, which offers authentic-looking capotes, capote kits and blankets for re-enactments. They make capotes from their blankets or from what the customer provides. As I held out for authenticity and for budgetary reasons, I began to scour eBay listings for Hudson's Bay four-point blankets. I should point out that beginning in 1890, the Hudson's Bay Company's point blanket makers in England began adding labels because point blankets of similar quality were being sold by HBC competitors such as Early's of Witney (now defunct), which formerly made point blankets for HBC.

From a book published by HBC titled *The Blanket* by Harold Tichenor, I learned that the Hudson's Bay point blanket label evolved over the years. The first successful bid I made for a Hudson's Bay point blanket proved to be of a rare vintage from the 1930s based on the label. It has a longer nap than the point blankets sold today, so I thought that it was more valuable as a blanket, and I use it on my bed during the winter months with the newer point blanket. The book mentioned that the 1950s label design with the "100% wool" designation was the most common of the older blankets, so I spent several months trying to bid on a Hudson's Bay point blanket of that vintage. I finally made a successful affordable bid around March 2010. These blankets usually go for top dollar on eBay. The blanket's green stripes were slightly faded, which gave it a satisfactory patina, but someone had sewn satin trim on the blanket—clearly not original. So before sending the blanket to the dry cleaner, I removed the trim, which left depressions where the stitching was.

After following Northwest Traders' instruction for making measurements, I ordered the Nor'Wester style with the hood and short cape. After I sent the blanket, I was informed that along the way, someone had laundered the wool blanket, making it shrink further. In the manufacturing process, point blankets are pre-shrunk to make them denser. The finished capote arrived in early April 2010 to my complete satisfaction. As it is a one-of-a-kind coat in

the Flint area, I have made it the desired coat to wear when going out during the winter months and when promoting my books.

During the winter months, I give my capote homecomings of sorts when I travel to Sarnia, Ontario, where I am surprised by how many nice people I meet there when I wear it, as the point blanket and capote are iconic to Canadian history. I was even encouraged to take part in War of 1812 re-enactments to note its bicentennial. Among those admiring my capote are First Nations members, as Sarnia is home to the Aamjiwnaang First Nation reservation. In the Flint area, people admire how warm the coat looks, which it is.

You can see a photo of me wearing my capote on the About the Author page.

Early Theater and Shakespeare in Flint

The face of English playwright William Shakespeare, who wrote plays in the late sixteenth and early seventeenth centuries, looked down from the proscenium arch above the stage of Flint's very first theater. Fenton Hall was located on the top floor of the three-story Fenton Block, which was built by Colonel William Fenton, after whom the city of Fenton was named. Opened on April 9, 1866, it was located at the southeast corner of Saginaw and Kearsley Streets.

At the time Fenton Hall opened, Saginaw Street was still a dirt road. Notable performers of the time who graced the stage of Fenton Hall included Edwin Booth (John Wilkes Booth's brother), Helena Modjeska (whose life story is the basis of Susan Sontag's award-winning novel *In America*), John McCullough (who in death became the star of theatrical ghost stories throughout the country), Lawrence Barrett (who made his stage debut in Detroit in 1853) and legendary opera singer Emma Abbott. Notable lecturers also appeared at Fenton Hall, including "The Great Agnostic" Robert Ingersoll, abolitionist Henry Ward Beecher (brother of *Uncle Tom's Cabin* author Harriet Beecher Stowe) and civil rights and feminist icons Susan B. Anthony and Anna Dickinson. Politicians who spoke there included future U.S. presidents James Garfield and William McKinley. Local talent also graced the stage of the six-hundred-seat Fenton Hall.

Fenton Hall saw continuous use for almost twenty years. But the theater's inadequacies prevented it from presenting grander productions. So after several years of wishing, an opera house was built. The Fenton Building was

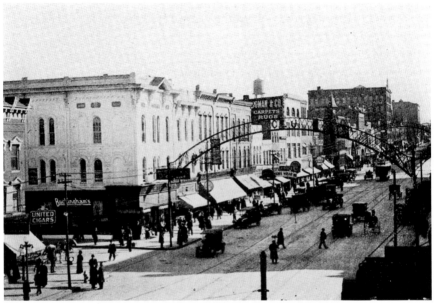

Above: Early photo of Saginaw and Kearsley Streets showing the Fenton Block (Buckingham's) where Flint's first theater, Fenton Hall, was located. *From History of Genesee County Michigan by Edwin O. Wood, published in 1916.*

Right: An 1866 ad for Fenton Hall in the *Wolverine Citizen*. *Courtesy of the Flint Public Library*.

ROBERT

HOUDIN,

THE RENOWNED

PRESTIDIGITATEUR,

WITH HIS DAUGHTER

CAROLINE HOUDIN,

AND THE

ARAB BOY,

WILL APPEAR AT

FENTON HALL,

ON

Thursday & Friday Evenings, April 19 & 20,

IN THEIR

MARVELOUS FEATS,

Tickets 50 Cents. Children, 25 Cents.

150 PRINCELY GIFTS

Will be distributed among the Audience. Doors open at Seven, to commence at Eight.

torn down in 1928 to make way for the Kresge Building. A flat lot is now on the former site.

On July 25, 1883, the cornerstone was laid for what was first called the Music Hall. It was a civic project spearheaded by the Flint Conservatory of Music. The cornerstone-laying ceremony was a grand affair, led by Gardner's Flint City Band. Starting at the corner of Saginaw and Union Streets, the procession also included members of the Masonic Lodges, Odd Fellows Lodges, the Clio Cornet Band, the Knights Templar, stockholders of the Music Hall and city officers followed by ordinary citizens in carriages.

The Music Hall opened on December 10, 1883, with the famous grand opera prima donna Emma Abbott. Tickets for the new 1,200-seat venue's opening performance were auctioned off at Flint's most luxurious hotel at that time, the Carlton House (later renamed the Bryant House). The successful winner of the first ticket was William Atwood, who beat out others with a $10 bid (or $244 in 2016 dollars).

Yet within a decade, budget shortfalls led to the sale of the music venue a decade later to local businessman Oren Stone (1833–1897), who served as Flint's mayor in 1888–89. After acquiring the Music Hall, he renamed it Stone's Opera House. His partner and manager was Herbert A. Thayer (1854–1899), who also operated the short-lived Thayer's Opera House at the corner of East Union Street and Brush Alley in the 1890s. Stone's Opera House was Flint's only good auditorium for several years, holding high school graduations and official gatherings of many types.

First lit by gas lights, Stone's Opera House was later wired for electricity. Shows that played there included *Evangeline*, *The Wizard of Oz*, *The Old Homestead*, *Streets of New York*, *Fantasmo*, *Isle of Space*, *Faust* and the blockbuster *Uncle Tom's Cabin*. Performers included Henry Miller, Louis Mann, Robert Edeson, James Hackett and former champion boxer John Sullivan.

In 1913, the Stone family leased the opera house to Colonel Walter S. Butterfield, who, in 1905, had built Flint's first vaudeville theater, the Bijou, just around the corner. Vaudeville theaters provided live variety shows in which itinerant performers traveled around the country to provide family entertainment in towns large and small. The Bijou only seated 1,092, so the larger opera house could stage more popular performers. After renovations, Stone's Opera House was renamed the Majestic Theatre. As the Majestic, it hosted such performers as "the most famous actress the world has ever known," Sarah Bernhardt, silent film stars Alla Nazimova and Lou Tellegen and future "talkie" sensations Al Jolson and the Marx Brothers. Read about the Marx Brothers in chapter 16.

As Flint grew, larger and grander theaters were built. The Palace Theatre (see chapter 19), just a block north of the Majestic Theatre, seated 1,348. This left the Majestic with cheaper, less renowned roadshow acts until it went dark in 1921. It was torn down in March 1923 to make way for the *Flint Journal*'s new home and now houses Michigan State University's College of Human Medicine.

On January 21, 1889, a few members of the Ladies Art Class invited their husbands to meet with them at Mrs. Ira H. Wilder's home to organize an evening club of men and women for the reading and study of the works of Shakespeare and Shakespearean literature. First nicknamed the "Art Club Annex," this was the start of the Flint Shakespeare Club. It initially had around three dozen members, including members of Flint's elite.

Today, the members still read Shakespeare's plays, one act at a time, three plays a year, like they did

An 1895 ad for the Music Hall for a presentation of *Hamlet* in the *Flint Daily News. Courtesy of the Flint Public Library.*

in 1889. Membership is limited to forty people who take turns reading plays. A committee chooses the reader. As with most clubs, this club also conducts normal club business at meetings. Over the years, members of Flint's elite have been members of the club, including Charles Stewart Mott and J. Dallas Dort.

Since 2005, Flint Shakespeare Club member Kay Kelly has been holding Shakespeare in the Park at Kearsley Park. Kelly is the artistic director of the Kearsley Park Players.

So, whether the works of Shakespeare are performed on stage or in private homes, it seems that, even in Flint, the Bard is alive and well. So, unlike most of Shakespeare's works, I have no tragic ending.

28

4

Flint's Cross-Dressing
Civil War Soldier

On the grounds of the Genesee County Courthouse, you will see a Michigan historical marker paying tribute to Flint resident Sarah Edmonds, who fought in the Civil War disguised as a man named "Franklin Thompson."

Edmonds was born in Magagudavic, New Brunswick, Canada, in 1841 and lived a hard life on a farm with an abusive father. She ran away from home at fifteen to avoid an arranged marriage and escape a life of enslavement. Inspired by a book she read, *Fanny Campbell, The Female Pirate Captain, A Tale of the Revolution*, she disguised herself as a man and assumed the name Franklin Thompson in order to have an easier life working as a book salesman. Fearing that her true identity would be revealed, she moved west and settled in Flint, where she continued to live as a male book salesman.

When the Civil War broke out in 1861, Franklin Thompson signed up and joined the Second Michigan Infantry and was assigned to be a male nurse. Edmonds/Thompson saw action in the First Battle of Bull Run, and as part of the Army of the Potomac, she/he also saw action at the Second Battle of Bull Run as well as the Battle of Fredericksburg. She/he also served as a mail carrier and performed other duties of a soldier. When an opening came up for a Union spy, the adventurous Edmonds, as Thompson, charmed the Union generals, who gave the new assignment to her/him.

Edmonds was able to successfully pass for a man because of the muscular build she developed from farm life and her flat chest. As a spy,

Drawing of "Franklin Thompson" and Sarah Edmonds. *Original artwork by Jennie Moench.*

Thompson was a master of disguise. The first disguise was as a black plantation worker named Ned Cuff. Employed as a slave as part of a work gang behind enemy lines toward Yorktown, Virginia, he worked on Confederate fortifications, was able to determine the town's defenses and made a map of the artillery placements, which he hid in the sole of his shoe. He almost blew her/his cover when the makeup began to wear off. A crude mixed-race joke and extra makeup allowed him to keep her/his cover, and he sneaked away to deliver the map to Union general George McClellan, who was thrilled.

After successfully passing as a man, Edmonds was able to live as a woman again by becoming an Irish peddler named Betty O'Shea. She went behind enemy lines, selling pies and cakes to unsuspecting Confederate officers who unknowingly passed along sensitive information.

In another assignment, she passed the rebel lines in Virginia and disguised herself as a female slave cook who provided rations to Rebel troops and was able to overhear and document battle plans. In total, Thompson engaged in eleven successful spy missions for the Union generals.

Drawing of Sarah Edmonds in disguise as a contraband slave. *From Edmonds's book* Nurse and Spy in the Union Army.

But in 1863, as Vicksburg was about to be captured, Edmonds contracted malaria. Denied a furlough and concerned that her true identity would be revealed in an army hospital, Thompson deserted, and Edmonds checked into a private hospital in Cairo, Illinois, for treatment. After discovering wanted posters for the deserter Franklin Thompson, who would be shot if caught, Edmonds spent the rest of the war as an ordinary female nurse in a Washington, D.C. hospital and treated wounded soldiers under her own name.

She wrote a bestselling book of her Civil War adventures titled *Nurse and Spy in the Union Army*, published in 1865.

In 1867, after the Civil War ended, Edmonds returned to Canada, where she married an old friend, Linus Seelye, and raised three of their own children—who never reached adulthood—and adopted two others. The Seelyes left Canada and moved first to Fort Scott, Kansas, and then to LaPorte, Texas.

But the effects of the malaria she contracted took its toll with the resulting poor health. Two decades later, she returned to Flint and made contact with her former comrades, who helped Seelye in her appeal for back pay, bounty and a pension, as well as removing the stigma of being a deserter. She began corresponding in March 1882 to convince the powers that be that Sarah Edmonds and Franklin Thompson were one and the same.

It took a few years and several letters from her, her comrades in arms and her commanders. First, for her service as an army nurse, a bill was signed on July 7, 1884, by President Chester A. Arthur giving her a pension of twelve dollars a month. But she still had the stigma of being a deserter attached to her Thompson identity. Also, in 1884, she attended a reunion with about ninety former members of the Second Michigan in Flint, and her fellow solders found out that Private Thompson, whom they knew as an affable soldier, was actually Sarah Emma Edmonds in disguise, which made news headlines around the country. She did not identify her regiment in her book, which explained why it took her fellow soldiers twenty years to discover her true identity.

It took two more years, but finally, on July 7, 1886, a bill was signed by President Grover Cleveland giving her an honorable discharge from the Union army, removing the charge of desertion from the record and settling the amount of back pay, bounty and allowances.

In 1897, she became the only female member of the Civil War Union soldiers' veterans' organization, the Grand Army of the Republic (GAR), when she was mustered into the George B. McClellan Post, Number 9.

Sarah Emma Edmonds Seelye died on September 5, 1898, and was buried at Morgan Cemetery near LaPorte, Indiana. At the request of her fellow members of the George B. McClellan GAR post, she was reburied with full military honors at the GAR plot in Washington Cemetery in Houston, Texas, on Memorial Day 1901.

Forgotten Thread Lake

This is the story of a waterway close to downtown Flint that you would think would be heavily used when the weather is warm. But fate over the years would prove otherwise.

Back in the early 1800s, industry required power from steam, wind, water or animals. Thread Creek fed Swartz Creek, which fed the Flint River. The first dam on Thread Creek was built to power a sawmill built by Rufus Stevens. But this dam was closer to Grand Blanc than Flint.

The current dam, which created Thread Lake, southeast of downtown, was built in the 1880s. It is located at the curve at which Clifford Street becomes Lippincott Boulevard. It was used both for recreation and industry. The most notable industry served by Thread Lake was the ice industry. Ice was harvested at the surface of Thread Lake and stored in insulated icehouses that kept the ice frozen all summer. The most notable ice company using Thread Lake ice was the Wildanger & Flanders Ice and Coal Company, which was founded in 1904 by William Wildanger—who headed the Flint Brewing Company and sold his interest in the brewery in 1903 to enter the ice business—and Francis Flanders. The firm also sold coal, wood and coke for fuel as well as ice.

In those days, icehouses were insulated by sawdust, which made them highly flammable. Around 1894, another ice business along Thread Lake lost a number of icehouses to fire. In 1909, the Wildanger & Flanders ice business lost three icehouses to fire on the same site. The 1909 fire was blamed on boys smoking or playing with matches. An employee was severely

burned trying to sound the fire alarm. New icehouses were quickly built, and it was decided to also build a plant allowing for the manufacturing of ice with refrigeration equipment, negating the need for Thread Lake ice.

Tragically, William Wildanger committed suicide by a gunshot at one of the icehouses on November 5, 1912, at age forty-seven. At the time of Wildanger's death, the ice business he co-owned was grossing $250,000 annually. Wildanger was buried at Avondale Cemetery. His estate and Flanders sold the ice business, which became Flint Spring Water Ice Company at 2021–25 South Saginaw Street. Flanders then entered the sporting goods business. Flanders died on January 2, 1940, at age sixty-two after a three-month illness and is buried at Glenwood Cemetery. By 1918, Flint Spring Water Company was located at 2125 South Saginaw Street. By 1928, it had evolved into City Ice & Fuel Company and remained at the same address. Later known as City Products Corporation, it went out of business around 1977. In 1979, there was a brief attempt at adaptive reuse when the Ice House Cocktail Lounge opened up. But it lasted only a year. A couple of years later, the former ice business was destroyed in a suspected arson fire.

Recreational use of Thread Lake was advanced by the opening of Lakeside Park, an amusement park, on May 30, 1913. The main attractions that day were high-wire acrobat performer James Hardy and the Moose Band. Admission price was ten cents for adults, free for children.

Lakeside Park offered vaudeville entertainment, band concerts, dancing and Fourth of July fireworks along with the rides, which by 1920 included seaplane rides, a giant roller coaster of which part went over the lake, a lavish merry-go-round and canoeing. Baseball games were also held there. The notable House of David religious commune baseball team from Benton Harbor with its long-haired and bearded members played there on July 4, 1931. Promotions and amateur contests were also held. A Buick coupe was given to a lucky patron in 1927. For Lakeside Park's "sweetie dances" in 1930, men were charged fifty cents and women admitted for free.

Lakeside Park closed permanently after its final day for the season on Labor Day 1931, when an actual wedding was held there along with a big parade. The ongoing effects of the Great Depression, along with competition from rival Flint Park across town, took its toll on Lakeside Park.

The owners of the closed park received an offer for it but held out for more money. They should have taken the offer, as the City of Flint took possession of the park for back taxes. The city tore down the amusement park structures and annexed it with adjacent Thread Lake Park. The combined park was

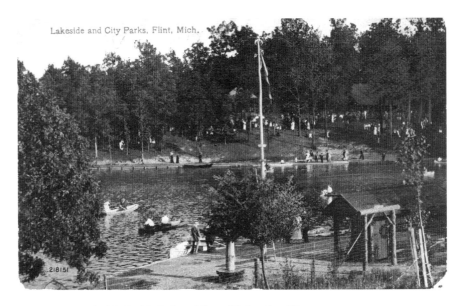

Vintage postcard of Lakeside Park on Thread Lake. *Gary Flinn.*

renamed McKinley Park on July 4, 1942, in memory of former Flint mayor and longtime parks administrator George E. McKinley. The entrance at the corner of Peer Avenue and Collingwood Parkway still has portions of the old Lakeside Park gate standing.

As time went on, Thread Lake had become increasingly isolated, making public access hard to find. Construction of I-475 along the lake's western shore inhibited access, forcing those who wish to enjoy the lake to take one of the side streets from South Saginaw Street between the I-475 overpass and Applegate Chevrolet. McKinley Park's surroundings look rather dismal indeed with simple frame houses often in poor condition. In taking in the park, the only person using the lake was operating a radio-controlled boat from shore. But during the winter months, the lake is popular with motorcycle ice racers.

Thread Lake also shows the socioeconomic divide of the Flint area. As Collingwood Parkway becomes Lakewood Drive around the southern shore of the lake, the shallow lake looks stagnant and dismal with many lily pads. Also, the simple houses on the southwest part of the lake give way on Lakewood Drive to larger and nicer homes as we pass by the private Flint Golf Club, where Flint's elite go to for fun, recreation and fine dinners.

Billy Durant

A Riches to Rags Story

The development of Flint into a major city can be credited to one man— William Crapo Durant—who ran the largest carriage company in the city and founded two car companies whose products are still being made today. A born salesman and wheeler-dealer, Durant took major risks that led to big successes and eventually his downfall.

Durant was the grandson of lumber baron and Michigan governor Henry H. Crapo. He was born on December 8, 1861, in Boston, to a banker who married one of Crapo's daughters, Rebecca. The marriage faltered, so Rebecca moved back to Flint with her two children. Following the death of her mother in 1875, Rebecca used her inheritance to buy a large home across from the then-new Flint High School at the corner of Church and Second Streets. Durant dropped out of high school at age seventeen in 1879 and went to work at the family lumber mill. Instead of getting an office or sales job, he was put to work stacking lumber for seventy-five cents a day. He supplemented his income by working as a clerk in a drugstore where patent medicine was produced. His interest in the medicine led to his giving up his mill and clerk jobs, and he began selling medicine to farmers around the area.

Durant then turned to selling cigars for a local cigar maker. A born salesman, he was successful in selling the stogies, and the business expanded—or make that overexpanded and lost money. Durant then worked for the local water works, where he made improvements that helped the utility business. He later went into real estate and construction.

In 1885, Durant bought his own house and married Clara Miller Pitt. They had two children. In 1886, Durant took a ride in a horse-drawn two-wheeled road cart with a unique suspension that cushioned the bumps. It was made by the Coldwater Road Cart Company in Coldwater. Durant and J. Dallas Dort bought the company and moved it to Flint, where it became the Flint Road Cart Company. In 1895, that company evolved into the Durant-Dort Carriage Company, which became the largest carriage company in the United States. In its peak year, 1906, it produced fifty-six thousand vehicles.

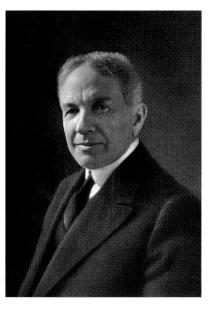

William C. Durant. *From the book* An Account of Flint and Genesee County from Their Organization, *edited by William V. Smith, published in 1924.*

In 1904, Durant entered the motor vehicle business by taking over operations of the struggling Buick Motor Company and made it very successful. In 1908, Durant founded General Motors, with Buick as a subsidiary of GM. Durant went on a buying spree, acquiring Oldsmobile of Lansing; Cadillac in Detroit; Oakland, which became Pontiac; various truck companies that merged into GMC; and numerous parts companies. He almost bought Ford but couldn't get the financing. Also, in 1908, Durant married his second wife, Catherine, after his divorce from Clara.

In 1910, Durant found himself overextended, and the conservative eastern bankers cut off additional financing during an economic downturn. Durant was forced to turn control of GM to the eastern bankers to keep the company going and avoid bankruptcy.

Undaunted, Durant began to lay the foundation for another car company. Durant acquired the Flint Wagon Works factories along West Kearsley Street and teamed up with noted race car driver Louis Chevrolet to form the Chevrolet Motor Company in 1911. Like David Buick had a few years before, Louis Chevrolet left the company following disputes with Durant, who wanted to compete with Ford with mass-market motor vehicles, while Louis Chevrolet desired to have his name on a line of luxury cars.

The Chevrolet Motor Company became profitable, and that success allowed Durant to shake up the business world when his Chevrolet company acquired controlling interest in GM, allowing Durant to take back control in 1916. This was a win-win for fast-growing Flint and its Chevrolet and GM stockholders, who suddenly became wealthy.

Durant headed GM for four years before losing control of the company for the final time in 1920 during another economic downturn and losing a fortune trying to prop up GM's stock price. Durant lost control a few weeks before the landmark hotel bearing his name first opened. At the time Durant lost control, GM's new headquarters in Detroit was being built. It was first to be called the Durant Building but was renamed the General Motors Building after Durant lost control. You can still see the letter *D* inscribed in places on the façade at what is now the Cadillac Square Building. GM vacated it for the Renaissance Center in 1996.

But Durant would not give up, and he founded Durant Motors in 1921. The following year, Durant broke ground on a new factory along South Saginaw Street between Atherton and Hemphill Roads to build the Flint. The Flint was a brand that competed with Buick, one of several product lines Durant Motors produced. The Star was the low-end line to compete with Ford's Model T, and the Eagle was the next step up.

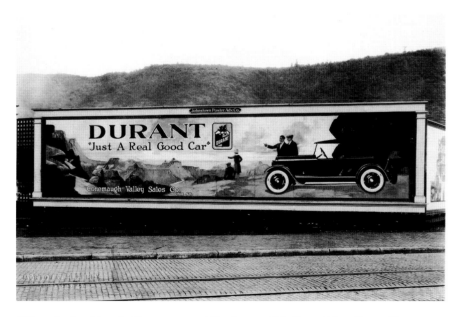

Billboard advertising the Durant automobile. *Courtesy of the Durant Motors Internet Forum.*

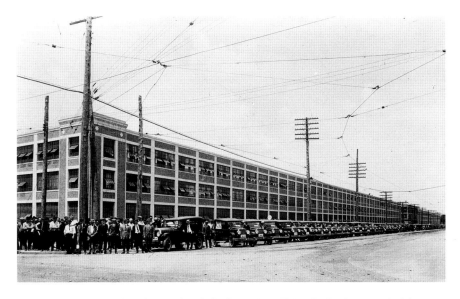

The Durant Motors Flint plant on South Saginaw (later Fisher Body plant no. 1) with a lineup of newly built Flint automobiles ready for shipment to Bay City. *Courtesy of the Library of Congress.*

The Durant competed with Chevrolet. The Princeton competed with Oldsmobile, and the Locomobile competed with Cadillac. Durant also made Mason trucks.

But Durant's Flint plant proved too large for the volume of business, so it was sold for $4 million to GM. For years, it was known as Fisher Body Plant No. 1 and made bodies for Buick. Today, it is the site of the Great Lakes Technology Centre. The plant's closing in 1987 was part of the basis for Michael Moore's documentary film *Roger & Me.*

The 1929 Stock Market Crash and the resulting Great Depression were devastating for Durant Motors and for Billy Durant. Durant Motors folded in 1931, and Billy Durant declared bankruptcy in 1936, listing his debts at $914,231 and assets (his wardrobe) at $250.

In 1940, Durant founded North Flint Recreation, a bowling alley not far from the Buick complex he had developed decades before. He had big plans for his scaled-down business, but it must have pained his friends, and his foes relished the fact that the seventy-nine-year-old Durant, the man who made Flint a major automotive center, was running a bowling alley. GM president Alfred Sloan did give Durant and his second wife, Catherine, a small pension.

Durant expanded his business by adding a restaurant, but time was running out on him. On October 2, 1942, Durant suffered a stroke at his

room in the Durant Hotel. He spent a month and a half recuperating at Hurley Hospital before leaving Flint for the last time on December 15, 1942, for his New York City apartment. His health gradually declined, and he died on March 18, 1947, at age eighty-five. He was buried at Woodlawn Cemetery in New York.

In 1958, at the developing Flint Cultural Center, Durant Plaza was dedicated to his memory. It is located between the Sloan Museum and Whiting Auditorium.

For further information about Billy Durant, read the book *Billy Durant: Creator of General Motors* by Lawrence R. Gustin.

J. Dallas Dort

Businessman, Flint Booster, Music Maven

J osiah Dallas Dort was not a Flint native, but he would become not only a prominent Flint businessman but also a major employer who helped boost the city population as well as a major contributor to the arts and recreation.

J. Dallas Dort was born in the Detroit suburb of Inkster on February 2, 1861, the son of a businessman and Vermont native. He attended Wayne High School and Ypsilanti's State Normal School. He left school to help his mother run the family business. His father died when he was ten. At age fifteen, he began to work at a crockery factory in Ypsilanti and moved on to work at a similar firm in Jackson three years later. Around that time, his father's estate was settled, and in 1881, Dort moved to Flint and was employed as a clerk for the Whiting & Richardson hardware store. Dort worked there for two years before he moved to Saginaw to work for the Morley Brothers firm. He was there for a year and saved enough money with help from his father's estate to establish his own hardware business back in Flint with business partner James Bussy.

In 1886, Dort sold his interest in the hardware business and invested $1,000 to begin his longtime partnership with Billy Durant. They bought the Coldwater Road Cart Company and moved it to Flint, where it became the Flint Road Cart Company, which initially employed twenty workers at a converted woolen mill that is still standing on Water Street at the Flint River. While Durant concentrated on marketing the road carts out of town, Dort supervised production back home. Shortly afterward, Dort married his first wife, Nellie Bates Dort.

J. Dallas Dort. *From the book* An Account of Flint and Genesee County from Their Organization, *edited by William V. Smith, published in 1924.*

The company sold 4,000 carts the first year. It greatly expanded, and in 1895, the business was renamed the Durant-Dort Carriage company. By 1900, Flint was producing over 100,000 horse-drawn vehicles per year, earning it the nickname "The Vehicle City."

Dort had other business interests. He helped to establish the Imperial Wheel Company; the Flint Varnish Works; the Flint Axle Works; the Dominion Carriage Company of Toronto; the Blount Carriage and Buggy Company of Atlanta, Georgia; and the Pine Bluff Spoke Company of Pine Bluff, Arkansas. Dort also had a hand in the Weston-Mott Axle Company, the McCormick Harness Company and the Copeman Electric Stove Company. He also invested in Buick and in General Motors and owned a farm that raised prize-winning horses.

Dort cared for his workers. He founded the Flint Vehicles Factory Mutual Benefit Association, which provided protection for workers in case of injury, illness or death. It was the forerunner of today's Industrial Mutual Association. He was also a city planner and served on park boards, with which he had a major role in Flint's development. He served as a director at Genesee County Savings Bank and was president of the Carriage Builders National Association. He had roles in the formation of the Flint YMCA, Hurley Medical Center, Atlas Valley Country Club and the Flint Golf Club.

Dort's first wife, Nellie, died in 1900 and was buried at Glenwood Cemetery. They had a son Ralph and a daughter Dorothy. In 1906, Dort married Marcia Webb, and they had three children: Dallas Webb, Margery and David Truscott.

That same year, the Dort family moved into their new, large stately home at the corner of Kearsley and Crapo Streets. This was also the year the Durant-Dort Carriage Company reached its production peak and had a role in reorganizing Buick.

But a rise in the sales and use of motorized vehicles led to the decline in sales of horse-drawn vehicles. So in 1914, Dort began to liquidate the

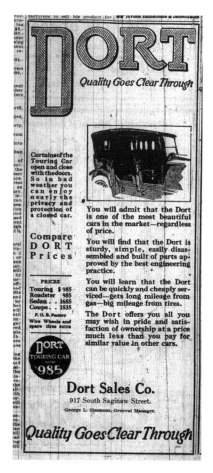

A 1921 Dort automobile ad in the *Flint Journal. Courtesy of the Flint Public Library.*

Durant-Dort Carriage Company, which ended production of horse-drawn vehicles in 1917. In 1915, the Durant-Dort facilities were utilized in the formation of the Dort Motor Car Company by J. Dallas Dort, who also built a factory on the east side of town.

Above all, J. Dallas Dort was a patron of Flint culture. So were his wives. In 1890, Nellie founded one of the oldest organizations devoted to music in Flint, the St. Cecilia Society, at their home. In 1913, he founded the Choral Union, which was a musical organization to benefit the city. In 1917, he provided the funds to establish the Flint Community Music Association, the forerunner of the Flint Institute of Music. Both J. Dallas and Nellie were accomplished musicians. He played the cello, and the Kearsley Street home was fitted with an Aeolian pipe organ he liked to play for guests.

Tragically, J. Dallas Dort was stricken by a heart attack and died while playing at the Flint Golf Club on May 17, 1925. The entire Flint area grieved his passing, with many tributes given by his friends and associates. His old business partner Billy Durant mourned, "Mr. Dort and I were partners for 38 years. I knew the man. Flint has lost its best citizen. I have lost my best friend. I am completely crushed." Charles Stewart Mott added, "I am terribly shocked by the sad news of the passing of Dallas Dort. He was my very main personal friend. Flint had lost its best citizen and one who never tired of giving his limit in work and wherewithal." Dort's death and tough competition in the 1920s led to the closing of the Dort Motor Car Company in 1925. The newer Dort factory on the east side was sold by Dort in 1924 to become the core of AC Spark Plug's main production facilities on Dort Highway, which was named in Dort's

The Dort family home on East Kearsley Street where the J. Dallas Dort Music Center now stands. *From the booklet* Flint's Community College and Cultural Center *by the Committee of Sponsors for the Flint College and Cultural Development Inc. and the Flint Board of Education, published circa 1958.*

memory in 1926, as the state trunk line bypassing downtown utilized most of Western Road, which Dort had first proposed.

Dort had ideas about boosting Flint even further, which he had planned to reveal a month later had he not died. His widow, Marcia, continued to live in the Kearsley Street home until she turned it over to the Cultural Center for use as a music school in 1958; it became the Dort Music Building. The Dort family contributed greatly to the facility's expansion, but during construction of the expanded Dort Music Center, which would have utilized the old Dort home, it was destroyed by fire in 1970. Marcia Webb Dort died in 1978. The Dort Music Center, housing the Flint Institute of Music and the Flint Symphony Orchestra, is a lasting legacy to the Dort family's contribution to the arts. Read more about the Dort Music Center in chapter 27.

William A. Paterson

Carriage Maker, Auto Builder, Real Estate Developer

F lint was still a small town when William A. Paterson arrived in 1869 to establish a buggy repair shop. The shop evolved into a carriage factory and later an automobile factory.

Paterson was born in Guelph, Ontario, Canada, in 1838 to Scottish immigrants. Raised in Guelph, he learned the carriage trade and became a proficient journeyman craftsman at age eighteen. In 1857, Paterson immigrated to the United States, where he plied his trade first in New England, then in Kentucky at the time of the Civil War. During the war, he moved to Illinois and worked in a factory that made horse-drawn ambulances. After the war, he and his two brothers established a wagon factory back in Canada in Kincardine, Ontario.

In 1869, Paterson moved to Michigan, where, after spending a few months in Pontiac, he settled in Flint to form his buggy repair shop at 617 South Saginaw Street. Originally, it was a one-man operation. But by 1885, Paterson was employing three dozen workers and building a buggy and a cart each day. By 1885, Paterson had established a brick factory and by 1901, he was producing twenty-three thousand vehicles a year and employed 350 workers. It has been said that Paterson forged the cross that tops the spire at St. Paul's Episcopal Church across from Paterson's carriage factories along Third Street.

Incorporated in 1896, W.A. Paterson Company had grown into a three-building complex along East Third Street between Saginaw and Harrison Streets. His office fronted South Saginaw, and behind the office building,

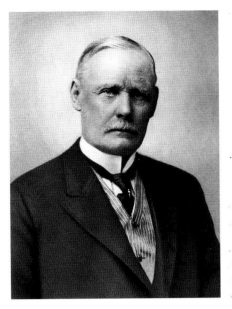

The Paterson-Six Forty Six
Is a Good Car

We use the Continental Red Seal Motor, and the
trimming is genuine leather over the celebrated Marshall
Springs.
Call and see the 1920 model at

1221 North Saginaw Street
We cannot guarantee prices but can make immediate
deliveries to Genesee County buyers

Maines Motor Co.
Phone 95 or 4299-W.

Left: William A. Paterson. *From the book* An Account of Flint and Genesee County from Their Organization, *edited by William V. Smith, published in 1924.*

Right: A 1920 Paterson automobile ad in the *Flint Journal. Courtesy of the Flint Public Library.*

across Brush Alley was a three-and-a-half-story factory with a four-story addition along Harrison Street that was built in the 1880s or '90s. Across Third Street behind St. Paul's Episcopal Church was a five-story factory built in 1905. A tunnel underneath Third Street that was built in 1909 connected the two factory buildings. It was used to transport wagons started in the older factory to the newer factory for completion.

In 1908, Paterson began assembling automobiles and discontinued carriages around 1910. The cars were well built and developed a loyal following, with a dealer network covering the United States.

Along with carriages and automobiles, Paterson was also a developer of residential and commercial buildings. In 1907, Paterson built the Dresden Hotel at the corner of South Saginaw and West Third Streets. It was named after Dresden, Germany, by Paterson's daughter Mary, who was impressed when she visited there. It was considered to be Flint's finest hotel until the rival Durant Hotel was built in 1920. Later renamed the Milner and finally the Adams Hotel, it was destroyed by a fire in 1963 that claimed two lives and forced the evacuation of one hundred guests. An addition to First Presbyterian Church was built on the hotel's site. The three-story Inglis

Building was named after Paterson's mother's family. The Inglis was the last remaining Paterson family–owned building when it was sold in 1962 and torn down the following year to make way for a Montgomery Ward store. It is now the McCree Building. The Dryden Building, named after Paterson's wife's family, is still standing. Built in 1902, it was gutted by a fire in 1926 that left only the outer walls standing. Originally six stories, it was rebuilt as a five-story building. The sixth floor had the first large ballroom in the city. Paterson also built private homes. One home Paterson built in 1907 for his son is still standing at 307 East Third Street at Wallenberg and today houses the Martin J. Banks Funeral Home.

Paterson continued to run the W.A. Paterson Company until he died in 1921. He son was unable to keep the company going, and it was sold in 1923 to car dealer Dallas Winslow. But the company was shut down the same year. The Paterson office building was destroyed by fire and rebuilt in 1931 in an art deco style. For years, it housed the McKinnon & Mooney Insurance Agency.

The two former factory buildings across from each other on Third Street at Harrison were converted to other uses. In 1926, the five-story former factory was sold, with plans to convert it into an apartment building along with two adjoining structures. The first floor became retail space. Two years later, it became the original home of the Flint Institute of Arts. For years, the first floor was occupied by Brownson-Fisher Wallpaper & Paint, a partnership of the building's owner, Charles M. Brownson, and Osman E. Fisher. Around 1963, the wallpaper business was sold to Fisher Wallpaper & Paint, but the Brownson name remained until the early 1970s. The Brownson family continued to own the building until it was sold in the 1990s to the Farah family, which also owned the Capitol Theatre. Other tenants in the Brownson building over the years included Baker Business College, a Social Security office, THY Design, the Internal Revenue Service, B&B Tile and Acme pattern shop. Brian Brownson was able to get the building a state historic designation in 1981, and it was listed in the National Register of Historic Places in 1984.

But in 1996, the west wall of the building across Brush Alley from St. Paul's Episcopal Church collapsed, rendering the Brownson building unsafe and threatening the historic church, which was older than the former factory. That unfortunately forced the Brownson building to be torn down. The church bought the condemned building, tore it down and made it into a parking lot. Some of the bricks were saved for the construction of a wall, and a historic marker was installed giving the history of the site.

The former Paterson factory buildings on both sides of East Third Street at Harrison. The factory in the background became the Brownson-Fisher Building and across Third Street behind the Capitol Theatre was the Pengelly Building. *Courtesy of Sharp Funeral Home.*

As for the older former factory building, it had been sold by 1928 to J. Bradford Pengelly, the former rector of St. Paul's Episcopal Church, who chose a new career in real estate. It was renamed the Pengelly Building and converted into an office building with space for forty offices and six storefronts. It mostly housed labor unions and was the base of operations for organizing the 1936–37 Flint sit-down strike. Among the labor unions occupying the Pengelly Building in 1936 were the Brotherhood of Painters, Decorators and Paper Hangers Local 1052, the Building Trades Hall, Bricklayers Union Local 12, the Truck Drivers Union Local 332, Flint Federation of Musicians Local 542, the International Brotherhood of Electrical Workers, the Federation of Labor Auditorium and the following United Automobile Workers unions: Locals 8, 29, 36, 29 and 43. At that time, the building also housed a violin maker, the Morris School of Violin, a music teacher and Bois & Company Real Estate, as well as the Pengelly real estate business. Read more about Pengelly in chapter 18.

But Pengelly lost ownership of the Pengelly Building in 1932 in a mortgage foreclosure. It went through three different owners in the next few years.

But even during the sit-down strike, the aging building was considered to be a rickety firetrap. A water tank on the building's roof was a source of complaints until it collapsed three stories into the basement due to the excess weight. It took several months to clear the debris and repair damage to offices and stores. In February 1942, the Flint Federation of Labor announced that it and the Flint and Genesee Building Trades Council were vacating the Pengelly Building for the Industrial Building, the former Industrial Savings Bank Building that was later renamed the CIO Building and even later the Metropolitan Building. Today, the old Industrial Savings Bank Building is part of Northbank Center.

The Pengelly Building was vacated because of renovation plans. But after Pearl Harbor and America's entrance into World War II, the federal government prioritized and refused to rehabilitate the building. Dilapidated and boarded up, the Pengelly Building was sold to Hamady Bros. Food Markets in 1946 and torn down. The bricks were salvaged to provide building material for the postwar veterans' housing program. Due to postwar material shortages, the site became a parking lot.

At the time of the Brownson building's demolition, part of the old tunnel was uncovered. It was an arched brick tunnel eight feet tall and fifty feet long. It was buried in sand on the Brownson building side at the time of demolition. The Pengelly side of the tunnel was used as an office for the parking lot. In 1954, a Hamady Bros. Food Market was built on the former site of the Pengelly Building. Later used as a Skaff Furniture store, the building now houses the Ennis Center for Children.

So, when you pass by the Dryden Building and the Paterson Building and look at the steeple of St. Paul's Episcopal Church, remember William A. Paterson, the pioneering carriage maker, auto builder and developer who made those landmarks possible.

Smith-Bridgman's

Flint's Largest Department Store

The year is 1862. Flint's population was three thousand. The March 29, 1862 issue of the *Wolverine Citizen* featured a grand opening ad for a new dry goods store operated by William L. Smith and Company. Flint at that time was a lumbering town and a center for farmers. The store was located on the right half of the Brockway Block building, sharing that building with People's Bank. It was originally a partnership between Smith, from Middlebury, Connecticut, and F.W. Judd, from Cleveland, Ohio. Judd operated his own dry goods store in the Fenton Building at the corner of Saginaw and Kearsley Streets. Along with cash sales, the store also bartered with farmers in exchange for their goods. It also offered goods to peddlers, who traveled by wagon and resold the goods in rural areas.

Judd sold his interest in the business and established his own shop in 1866. Charles T. Bridgman was an employee of the firm who as a boy started by wrapping packages in the grocery department. He invested money and became a partner in 1871. The business was renamed Smith, Bridgman and Company. In 1897, William Smith's son Walter O. Smith joined the partnership along with his uncle Eli. Within a few years, it had outgrown its original 5,625 feet of floor space and took over the bank's half of the building. In 1908, it took over another building south of the original store, which became an annex. In 1913, the original building was renovated with a terra-cotta front façade.

In 1918, Smith-Bridgman's was acquired by O.M. Smith & Company. In 1923, it expanded into a seven-story building with an addition built on the

north side in 1936 and another addition on the south side in 1957, which also replaced the ornate front façade with a windowless modern façade.

In the 1930s, the Mott Foundation began acquiring stock in the business, which led to full ownership of the store. The Mott Foundation also acquired department stores in other Michigan cities. It also owned the J.W. Knapp Company in Lansing, D.M. Christian department store in Owosso and L.W. Robinson Company in Battle Creek.

Smith Bridgman's also had two annex stores downtown, one on the other side of Brush Alley facing Harrison Street and the other on East First Street, which was torn down in 1966 to make way for Genesee Towers.

In 1967, Smith-Bridgman expanded to the suburbs with the opening of a store in the Bella Vista Mall (now the Grand Mall) in Grand Blanc. In 1970, the Mott Foundation sold its department stores to L.S. Good & Company of Wheeling, West Virginia. But the 1970s was not a good decade for downtown retailers, with the rise of the suburbs and of suburban shopping areas. In 1979, Smith B's, as the store had come to be known by that time, was considering opening in a new store in a proposed shopping center on Linden Road. But it chose instead to open a store in Davison at 837 South State Road in the Davison Shopping Center.

But the parent company's mismanagement also had a role in the decline of Smith Bridgman's. It tried new concepts in 1979 with Smith B's V.F.Q. V.F.Q. stood for "Value, Fashion and Quality." It also established a closeout department at its downtown location called Finale, a new and exciting shop of extraordinary values. It featured clearance bargains collected from their top fashion departments and home furnishings from all of its co-owned Michigan stores all marked at 50 percent off or more. It also featured special purchases.

L.S. Good & Company filed for bankruptcy in May 1979. In November 1979, Smith-Bridgman announced it would renovate its downtown store and held a liquidation sale. The sale disappointed shoppers, as some found merchandise that Smith B's did not normally carry. Some of the downtown merchandise was moved to the new Davison store. Plans were to convert the large building into a vertical shopping mall, with Smith B's occupying three-fifths of the space. Hopes were that the University of Michigan–Flint would occupy some of the space. But that did not materialize, and the Smith B's downtown store was reduced to a scaled-down operation of its Finale clearance center and liquidation outlet for all of L.S. Good's Michigan stores, with the rest of the building's space empty. The downtown store closed permanently on June 4, 1980. When that store

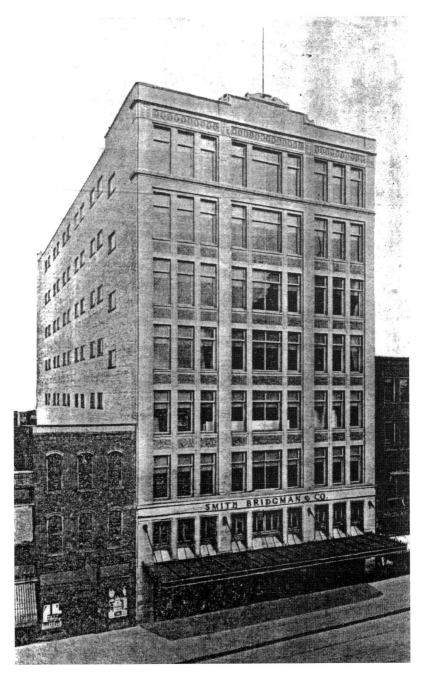

The seven-story Smith, Bridgman & Company store as it originally looked. *From A Pictorial Souvenir of Flint, Michigan "The Motor City" by Franklin L. Stevenson, published in 1928.*

closed, it marked the end of the oldest department store in Michigan and one of four west of New York State that had operated on the same site for more than one hundred years. The merchandise at the downtown store was shipped away for sale at L.S. Good's other stores. By that time, the fourteen-store operation had lost $6 million in recent years. A clerk at the closing downtown store blamed shoppers who shopped in suburban shopping areas instead of downtown in recent years. Indeed, Sears and Woolworth left downtown for the new Genesee Valley Center in 1970. JCPenney moved to the malls in 1980. The Vogue and Montgomery Ward also closed their downtown stores around that time.

On October 17, 1980, the remaining stores in Grand Blanc and Davison were ordered closed by a bankruptcy judge at L.S. Good's base of operations in Wheeling, West Virginia, thus closing the final chapter in the century-plus history of Smith-Bridgman's. The remaining L.S. Good–owned stores in Michigan—Knapp's in Lansing, Christian's in Owosso and Robinson's in Battle Creek—were also closed that same month. The inventory of the two remaining Smith B's stores was sold to a unit of Value City department stores based in Columbus, Ohio. Valued at $486,000, the merchandise was sold for $171,257. The buyer also bought the inventory of L.S. Good's remaining Michigan stores. The total sale price at the auction was $2.3 million. While Value City did operate a department store in Flint, it did not have a store in Flint at that time. The inventory was sent to Lansing for liquidation at the flagship Knapp's store in downtown Lansing, where thousands of shoppers jammed a liquidation sale that began on November 28, 1980.

The downtown store was torn down in 1984 along with the rest of the portion of downtown bounded by Saginaw Street, Riverbank Park, Harrison Street and East First Street as part of the development of Water Street Pavilion (now the University of Michigan–Flint's University Pavilion) and is now the parking lot. The art deco downtown Lansing Knapp's store had a better fate and was converted into an office building called Knapp's Centre, which was later converted into an apartment building with retail and restaurant space.

The Michigan School for the Deaf

Then and Now

The oldest institution to call Flint home predates the city. It opened in 1854, one year before Flint became a city, as the Michigan Asylum for Educating the Deaf and Dumb and the Blind. Colonel Thomas B.W. Stockton donated twenty acres of land on West Court Street to house the asylum. Now you know how Asylum Street got its name. The founding principal was the Reverend Barnabas M. Fay, who was brought over from the Indiana Institution for the Blind.

The following year, the first deaf teacher was hired, William M. Berg, who taught there for twenty-one years. Enrollment in 1855 was seventy, and the first permanent building opened in 1856. After expansion, it was named Clarke Hall. In 1861, the school purchased Lot 70 of Glenwood Cemetery for the burial of orphans enrolled at the institution. In 1868, the school transitioned from an asylum into an institution. Two years later, a vocational building was constructed.

In 1870, the administration building was constructed in front of Clarke Hall. In 1872, a print shop was added to the school, and in 1874, the first issue of the school newspaper, the *Michigan Mirror*, was published. In 1875, enrollment was more than two hundred students.

In 1880, a separate Michigan School for the Blind was established in Lansing. At that point, the school became the Michigan School for the Deaf (MSD). MSD's curriculum combined academics and practical training. Male students were taught such skills as carpentry, tailoring, printing and farming, and female students were taught how to cook and sew.

In 1890, the oldest surviving building on campus was constructed—the superintendent's cottage. Cabinet shop students decorated the interior. In 1900, Brown Hall was constructed.

On May 22, 1912, the administration building was destroyed in a spectacular fire. Its replacement was built on the same site the following year—the imposing and photogenic landmark Fay Hall. The Stewart Gym was built in 1926, and Gilbert Hall was built in 1932. In 1934, enrollment was over five hundred students.

In 1942, the service building was built, and in 1949, Stevens Hall replaced Clarke Hall. A new heating plant was built in 1953. By that time, enrollment was near capacity. In 1958, Fay Academy was completed and classes transitioned to that building. In 1967, a new health center was opened.

Enrollment was starting to level off; in 1969, there were over four hundred students. MSD abandoned Fay Hall in 1986. In 1991, MSD received its first deaf superintendent, Dr. Brian McCartney.

In 1995, Fay Hall, Stewart Gym and six acres of the campus were sold to the private Valley School for $135,000, which spent another $2.5 million on renovations. That same year, Michigan School for the Blind closed in Lansing, with blind students moved back to Flint, so the school was called the Michigan School for the Deaf and the Blind. To accommodate blind

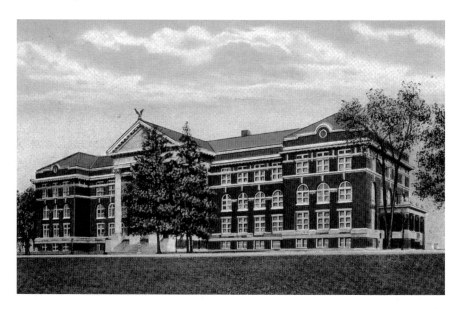

Postcard of Fay Hall on the Michigan School for the Deaf campus, now part of Powers Catholic High School. *Gary Flinn.*

students, Gilbert Hall became home of the Michigan School for the Blind, and cottages behind Gilbert Hall were used as dorms. In 1998, a new dormitory was built for blind students. But after a few years, enrollment of blind students leveled off, and when enrollment went down to just three blind students, the program for blind students was closed. Blind students in Michigan are now served by the Michigan Department of Education's Low Incidence Outreach program.

In 2005, MSD's enrollment was down to 150 students. That same year, MSD's Community Access Center installed video phones throughout the campus.

But Valley School wound up selling its facilities back to the state for $750,000 and leasing space before leaving the MSD campus in 2006. This left MSD with excess capacity, doubled with deferred maintenance due to budget cuts from the state. The Michigan School for the Deaf was encumbered with too many buildings and not enough funds to maintain them. But a creative plan to save MSD was hatched. Powers Catholic High School wanted to relocate from its location in Mount Morris Township on Carpenter Road to a better location closer to its population center.

In 2010, the state sold the Michigan School for the Deaf campus to developer Lurvey White Ventures with plans to build new facilities for the Michigan School for the Deaf and Powers Catholic High School, which will share the campus and its athletic facilities. Powers Catholic was attracted to the MSD campus location by its easy access from Interstate 69 at the Hammerberg Road exit and its central location in the city of Flint.

The first stages of construction began in 2011 on the east side of the campus, as two aging abandoned structures were torn down—Stewart Gym and the Brown Hall Annex—to make way for a new academic building, which was completed in 2012. Upon the opening of the new facility, the aging fifty-four-year-old Fay Academy was torn down to make way for construction of the new home for Powers Catholic High School, incorporating historic Fay Hall.

When renovation of Fay Hall began in the summer of 2011, the neglect the historic building went through since it was mostly abandoned five years before was obvious both inside and outside. Some parts of Fay Hall had not been used since MSD stopped using the building fully in 1986. Before renovations began, MSD used Fay Hall as the home of its Communication Access Center (CAC), which was moved to its present location in Gilbert Hall. While Lurvey White Ventures converted Fay Hall into modern classroom

space, it respected the building's history and consulted with Michigan's Historic Preservation Office in renovating Fay Hall.

The new construction for Powers Catholic included a gymnasium and auditorium. New athletic fields and related facilities were built and a library, chapel, kitchen and lunch facilities added.

The renovations gave Fay Hall at least another one hundred years of useful life. Fay Hall's cornerstone reads AD 1913, and the cornerstone of Powers Catholic's addition reads 2013.

Redeveloping "Chevy in the Hole"

After a decade of planning, development of the city-owned portion of the old "Chevy in the Hole" brownfield south of the Flint River is being developed into park land dubbed Chevy Commons in a multiphase project that could take several years to complete. Kettering University is redeveloping land north of the river into the GM Mobility Research Center.

The site west of downtown was the site of industry a century and a half ago. In 1865, the Begole, Fox & Company sawmill was developed on the south side of the river. But it closed when the supply of trees ran out in the 1880s. So the site was redeveloped for wagon building in 1884 when Flint Wagon Works opened. It grew rapidly, and by 1904, the site had become a self-sufficient complex of factories making not only vehicle bodies but also the wheels and seats for the vehicles. Flint became known as the Vehicle City from the production of horse-drawn carriages. At its peak, the Flint Wagon Works produced up to fifty thousand vehicles a year.

James H. Whiting, the manager of Flint Wagon Works, saw horseless carriages as the future of transportation and entered the motor vehicle business in 1903 by buying the Buick Motor Company of Detroit and moving it to Flint, where a factory was built on West Kearsley Street near the Flint Wagon Works. But Buick ran into financial trouble and was purchased by Billy Durant of the rival Durant-Dort Carriage Company. Durant's success with Buick led to the construction of a larger factory complex on the site of the old Hamilton farm in 1906 and the formation of General Motors in 1908.

Durant lost control of GM in 1910, as the conservative bankers who backed him financially were concerned about his free-spending ways on ventures they objected to.

The Flint Wagon Works also began making motor vehicles with the Whiting car from 1908 to 1910. Durant started a new enterprise using the Flint Wagon Works factories and formed the Little Motor Car Company in 1911. Little became the forerunner of the Chevrolet Motor Company, which was founded by Durant in Detroit in 1911, merged with Little and took over the Flint Wagon Works complex, including the old Buick factory in 1913.

With the chemical-making Du Pont family backing Durant financially, he shocked the business world by using the Chevrolet company to take control of GM again in 1916, merging the two companies. But Durant permanently lost control of GM in 1920.

By 1934, the factory complex covered eighty acres and employed fourteen thousand workers at thirty-one factories on both sides of the river. Fisher Body built Plant 2 across Chevrolet Avenue from the final assembly plant. An overhead tunnel spanning Chevrolet Avenue to transport bodies from one factory to the other became a local landmark, with the two-sided neon Chevrolet bow tie sign mounted on the tunnel's roof.

In 1984, activity started winding down with the shutdown of Plant 4, the engine plant. That year also started the reorganizing of GM's manufacturing operations, making Chevrolet strictly a sales organization with the establishment of the Chevrolet-Pontiac-Canada Group. When the Fisher Guide division took over the Chevy in the Hole complex by 1986, the neon Chevrolet bow tie sign came down. That sign was moved to Vic Canever Chevrolet in Fenton. In 1987, AC took over the complex and Delphi followed in 1995. Vacant buildings were torn down beginning in 1995, with Plant 4 the last building razed, in 2004. Kettering University annexed the site north of the river for campus expansion.

Two buildings remain. Plant 38 on Stevenson Street is still operated by GM and is now Flint Tool and Die. Plant 35 on the expanded Kettering campus was renovated and became the C.S. Mott Engineering and Science Center.

After the historic Chevrolet Avenue bridge was replaced in 2006, a memorial to the Chevy in the Hole site was developed, utilizing a section of concrete railing and the original lamp posts with the old Chevrolet Avenue paving bricks laid out in the same herringbone pattern as it was when the road was originally paved.

Vintage aerial view of the "Chevy in the Hole" complex postcard. *Gary Flinn.*

The former "Chevy in the Hole" site during demolition. *Courtesy of the Library of Congress.*

In 2008, the Flint Economic Development Corporation acquired the property for one dollar with a quitclaim deed from Delphi Corporation.

In 2009, the city began piling up bags of collected yard waste for composting. The plan at that time was to grind up the compost piles so the compost could be resold. But after a couple years of collecting yard waste, the odor from the decomposing material became such a problem downwind that it fell out of compliance with state law. When 2013 began, the city had almost 100,000 yards of compost at the site. But the city's financial problems prevented the compost from being processed fast enough.

At that time, at least eleven thousand yards of compost were committed to the reclamation of the Chevy in the Hole site.

In 2011, the city took over ownership of the site south of the river from the Flint Economic Development Corporation. The city also secured a $375,000 grant from the U.S. Forest Service and was expecting a $2 million grant from the Environmental Protection Agency. Once funding was secured, reclamation of the site began with both the planting of trees and the monitoring of the grounds in a low-maintenance process called phytoremediation. The trees will help absorb the contaminants, preventing runoff into the river.

In 2014, the city unveiled a multiphase plan for the development of the site into parkland dubbed Chevy Commons. The site would include grassland, shrubbery, wooded areas, open areas, wetlands and bike and pedestrian trails incorporating the Genesee Valley Trail, utilizing the old Grand Trunk Railway right of way connecting Genesee Valley Center with downtown Flint. In 2015, Phase One—which included trails and a parking area—was completed.

Meanwhile, Kettering University announced its plans for the Chevy in the Hole site north of the river with a project it called the Kettering University Student Automotive Research Area (KUSARA). Bounded by Chevrolet Avenue, Bluff Street and the Flint River, KUSARA is a project that will greatly enhance the learning process for Kettering students. It allows students to perform experiments and performance tests outside of the classrooms and labs and perform them in real-world environments. It includes a large autocross area, including a staging pavilion, a baja track, a rock crawl and a hill climb, along with a utility building to serve the KUSARA grounds. Very few colleges offer such a product development area. Construction began in 2016 on the first phase on the west end of the development along Chevrolet Avenue. With funding provided

by the General Motors Foundation, Phase One of the GM Mobility Research Center was completed in October 2016. That project involved construction of brownfield water and runoff management facilities, a 3.25-acre test pad meeting race track standards and landscaping, fencing and lighting.

12

Flint's Annexation History

The village of Flint was started in 1835. It occupied just over fifty-four acres, with the Flint River its northern border, Court Street its southern border, Saginaw Street its western border and Harrison Street its eastern border.

When it was incorporated into a city in 1855, its population was around two thousand. The city's borders at that time were the present downtown location with its initial north edge of town being Fifth Avenue, the western edge being Thread Creek, the southern edge Fifteenth Street and the eastern edge East Street.

The city's main industry at that time was lumbering. When the lumber supply in the area was exhausted, a woolen mill was Flint's main industry in the 1870s. From the beginning, there were small carriage factories, but the first major factory opened in 1869. The production of horse-drawn carriages evolved into the making of motor vehicles the following century. As Flint grew, the boundaries were enlarged with annexations in 1897, 1901, 1910 and 1920 as additional subdivisions and large industries were developed.

Expansion was stunted during the 1930s Great Depression. But World War II and the postwar years led to further development both inside the city and outside the city. This led to the formation of the Flint Area Study as a fact-finding group to figure out how to handle the Flint area's growth. Its findings led to a proposal by consultant Dr. Basil G. Zimmerman to greatly expand the city into "New Flint" covering an area over five times the size of Flint. A consolidated school district serving the area was also proposed.

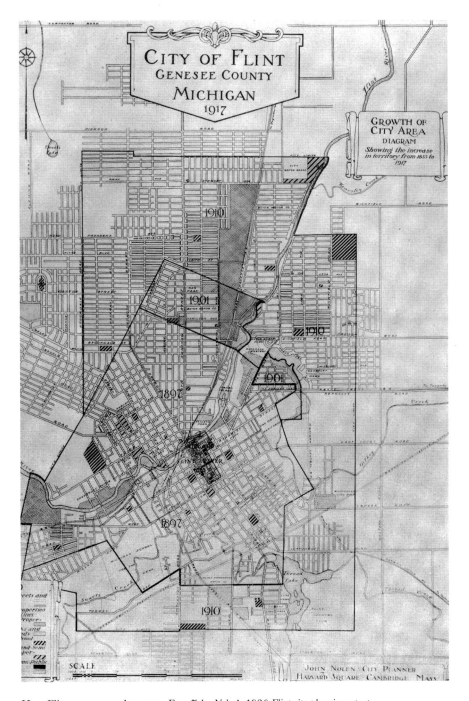

How Flint grew over the years. *From John Nolen's 1920 Flint city planning report.*

An organization was formed to promote the plan called the New Flint Planning Committee, led by chairman Harding Mott. The committee's legal counsels were Stewart Newblatt and Frank Killeen. Michigan's attorney general at that time and future Michigan Supreme Court justice Paul Adams ruled the New Flint idea was legal.

Supporters stated that New Flint would facilitate action on upgrading water and sewer services for all areas of the new city, promote job security for its people and their children and equalize educational opportunities.

Opponents formed the New Flint Resistance Committee, led by Louis Traycik, attorney for the Carman School District, and Carman Schools superintendent Frank Hartman as secretary.

In 1958, Carman had per pupil funding of $40,000, which was more than double that of the Flint School District and six times that of the neighboring Utley School District in central Flint Township or the Hoover School District in the northern part of Flint Township west of Flint. Carman's tax base in 1958 included the $68 million Chevrolet plants located at Van Slyke and Bristol Roads.

Opponents to the plan made a point of mentioning that the city of Flint had eighty-eight thousand registered voters, compared to fewer than forty thousand in the surrounding areas affected, so the affected cities and townships outside the city of Flint would have less of a voice in the formation of New Flint. The way the proposed ballot was set up, if the majority in the city of Flint voted *yes* and the majority in the affected out county areas voted *no*, the out county areas would still be absorbed into the new city. The New Flint Resistance Committee adopted a basic plank saying that the eleven municipalities affected by the New Flint proposal should be able to work out their problems "through agreement, metropolitan authorities or other manner, without destroying local self-government." It was estimated in 1958 that in 1965 there might be parity in the populations between the city and the out county areas. That theory may have been proven by the 1970 census, when Flint's population shrank from 196,940 to 193,317.

Opponents to the plan made it a point to avoid emotional resistance, as out county residents would not likely say "I love my septic tank and well" and succumb to the idea that they could get sanitary sewers, water lines and upgraded schools they could not otherwise afford and chose instead to aim their opposition pitch to city of Flint residents who would get an increased tax burden without showing any obvious long-term gains, as their increased taxes would go to upgrading services in the expanded out county areas.

City of Flint Census Tracts

MAP 5

Source: 1980 U.S Census

The city of Flint's present boundaries.
From the 1980 census.

Petitions to put the New Flint proposal on the ballot were filed on June 6, 1958. They were presented to the Genesee County Board of Supervisors on July 8. No errors were found on any of the signatures. Against the advice of the board of supervisors' legislative committee, the Genesee County Board of Supervisors voted 22 to 13 on August 12 to deny the petitions and 25 to 13 not to set an election date.

The New Flint Committee then filed a writ of mandamus with the Michigan Supreme Court on August 13 to force an election set for November 4, 1958. The court ordered the board of supervisors to answer the suit on August 14. The county filed its answer to the court on August 20. The following day, the court ordered a show-cause hearing set for September 9. On September 4, the county asked the Michigan Supreme Court to allow sixty days to prepare the case, but on September 9, a state tribunal denied the request and asked that all data related to the case be submitted to the Michigan Supreme Court by September 19. The tribunal agreed with New Flint Committee attorney Newblatt to allow typewritten briefs rather than printed briefs because of the short notice before the November election date. Final arguments were heard on September 19.

The Michigan Supreme Court ruled unanimously on October 8, 1958, that incorporation is not the legal way to create a new city on territory occupied by a duly incorporated city—in this case the cities of Grand Blanc and Mount Morris. The legal way to form a larger city is with consolidation, in which each city and township affected would hold separate elections to approve or reject consolidation.

Because of the out county opposition to the New Flint proposal, it was not practical to successfully hold separate elections for every affected city and township, so the idea died. On October 29, 1958, the New Flint Resistance Committee voted to change its name to the Genesee Metropolitan Planning Council. The Detroit attorney who led the successful fight, Charles B.

A 1971 ballot proposal campaign ad for the successful incorporation of Burton Township into a city from the *Flint Journal. Courtesy of the Flint Public Library.*

Cozadd, had reported to opposition committee members that he received full payment of his $7,500 fee for his part in fighting the New Flint proposal. The new committee would work with the out county governments and school districts in solving common problems.

Flint did annex adjacent land, including General Motors plants at Bristol and Van Slyke Roads, the Northwest Shopping Center, the South Flint Plaza and Bishop Airport. But plans to annex Burton Township's Eastland Mall (now Courtland Center) and an AC Spark Plug factory there led the township to propose incorporation into a city. Genesee Township and Flint Township had similar proposals for the cities of Genesee and Carman, respectively. In 1971, only Burton Township was successful in its ballot proposal, so the City of Burton was incorporated in 1972. The surrounding townships are charter townships, making it more difficult for Flint to expand.

Recalling Flint's Dairy Industry

F lint had a few dairies that produced milk products that were sold both locally and outside the Flint area. This chapter is about dairies based in Flint that were in business for several years.

The earliest such dairy was the Freeman Dairy Company, which dates to 1914 and was originally headed by Leonard Freeman. It was originally located at the corner of First Avenue and Garland in a building that was later converted to apartments. By the mid-1930s, it was known as the Freeman Company, still headed by Leonard Freeman with other members of the Freeman family in management positions and located at 1511 North Saginaw Street. Around 1941, it decided to specialize in ice cream and ice cream products and after World War II moved to 2159 North Dort Highway in a building now occupied by an Eagles lodge. By 1952, it was run by Dayton L. Grabill. Around 1954, it was renamed Freeman Ice Cream Company. In 1965, it was headed by Ernest G. Pappenheimer.

By 1979, Freeman Ice Cream had moved to a larger facility in Burton at G-3300 East Bristol Road. In 1982, it was sold to London Farm Dairy of Port Huron and became London's ice cream plant. It was converted from an ice cream novelty facility to a full line hard ice cream plant. After the parent company was sold to the owners of Grand Rapids–based Country Fresh Dairy, both the Port Huron milk plant and the Burton ice cream plant were shut down in a consolidation move, thus ending the Freeman Dairy Company story.

Flint families who use plenty of Freeman's pure pasteurized milk live better at the lowest cost of years!

Where Can You Buy Greater Food Value Than Freeman's Pure Pasteurized Milk at 10c per qt. ?

Why not take advantage of its wonder food value as a beverage and the richness and tastefulness it adds to the dishes you prepare when Freeman's Pure Pasteurized Milk is selling, as it is, at its lowest price in years—10c per quart?

FREEMAN DAIRY CO.

A 1922 Freeman Dairy ad in the *Flint Journal. Courtesy of the Flint Public Library.*

As Flint grew, another decade-spanning dairy sprang up under corporate ownership. Around 1926, managers G.E. Norwood and W.C. Trump started Arctic Dairy at 203 East Third Street and marketed ice cream. By 1929, the business had moved to 1364 Burton Street (now Robert T. Longway Boulevard), a building that now houses the Sloan Museum's Buick Gallery and Research Center. It also expanded into a full line dairy offering Glendale Farms dairy products: Golden Guernsey milk, cream, butter, cottage cheese and ice cream. By that time, C.D. Bridgman was the manager, and W.C. Trump ran the ice cream department. By 1930, L.R. Maine had become manager, and Michael T. Lynch took over in 1939.

In 1942, it expanded, adding another building next door at 305 South Walnut Street, which now houses the Flint Community Schools' food service facility. At that time, Michael T. Lynch was still the manager. The original building was being used as the ice cream department, run by Wendell E. Marquis. By 1945, it had become the exclusive distributor of Sealtest dairy products. While Lynch was still managing the dairy division, Richard O'Hearn Morris had taken over the ice cream division. By 1950, Albert P. Ruddy had become the manager.

By 1956, Sealtest Ice Cream was moved to another facility at 925 South Dort Highway, and other dairy products consolidated both adjacent buildings at Walnut and what became Robert T. Longway Boulevard. By 1959, the Sealtest Foods division of National Dairy Products Corporation had taken over the company, with Ruddy continuing to run the Walnut Street complex. Edward Shiple was running the Dort Highway ice cream department.

By 1962, Sealtest had moved to 712 East Fifth Avenue, run by Sheldon Olson, with the Dort Highway ice cream facility sold to Swift & Company. Finally, in 1963, it moved to 3418 Robert T. Longway Boulevard, and over the next few years, the company was run by Douglas Jones and then William Brooks. But the early 1970s was a time of contraction for Sealtest, which closed its Detroit plant on March 31, 1972, leaving Sealtest with only a plant in Lansing, which was sold in 1983. The rise in store brands was blamed for

Sealtest's decline. Back in Flint, William Brooks was the last listed manager at the Longway facility. It was still listed in the 1975 Polk directory, but the listing was absent in the 1976 directory. So it's believed that 1972 was the final year that Sealtest operated in Flint. Sealtest dairy products are still being sold in Canada.

Genesee Dairy was founded around 1930 by president and general manager Forbes K. Merkley and his wife, Martha, who initially served as secretary and later added treasurer to her duties. Forbes Merkley entered the dairy business working at Freeman Dairy. He then co-owned a dairy in Saginaw before selling that dairy to establish Genesee Dairy, which moved into space at 1023 North Saginaw formerly occupied by an ice cream company owned by former Arctic Dairy manager George E. Norwood. Norwood moved his ice cream company to 626 Harrison Street. Genesee Dairy added additional space for its dairy, whose initial address in 1930 was 1023–25 North Saginaw Street. In 1935, the Merkleys bought a rundown farm that they made into the For-Mar dairy farm and supplied milk to Genesee Dairy. That is now the For-Mar Nature Preserve and Arboretum (see chapter 31). By 1937, Genesee Dairy had added additional space, and the address from that time onward was 1021 North Saginaw. It was a full-service dairy offering milk, cream, butter, cottage cheese and Satin brand ice cream. After Forbes Merkley died in 1966, his widow, Martha, hired Charles L. Peterson to be general manager. Genesee Dairy was sold to McDonald Dairy in 1971, and the former Genesee Dairy location became storage for McDonald Dairy.

When brothers John J. and William A. McDonald resigned from Freeman Dairy to be their own bosses by purchasing the Independent Dairy Company at 210 East Eighth Street in 1929, there were fourteen dairy firms operating. In 1931, they moved into the brand-new McDonald Dairy plant on Lewis Street, now called Chavez Drive, which became the nucleus of a facility that would expand numerous times.

A 1953 Genesee Dairy ad in the *Flint Journal. Courtesy of the Flint Public Library.*

The McDonalds alternated managing their dairy. When they took over Independent Dairy, William was president. When it was reorganized into McDonald Dairy in 1931, John was president. They would continue to alternate running the company over the years.

In 1932, McDonald Dairy became the first dairy in the nation to successfully introduce homogenized milk.

In 1942, the McDonald brothers and the farmers serving the dairy reorganized the company into a nonprofit co-operative to be eventually owned by the milk producers after the McDonalds were eventually paid off with the dairy's proceeds from operations. The McDonalds continued to manage the company.

In 1945, McDonald introduced milk sold in square milk bottles for easy storage in refrigerators.

John McDonald died in 1947 at age sixty-two of a heart attack while inspecting his 230-acre model farm south of Grand Blanc, leaving William McDonald in sole command of the company.

In 1950, McDonald's growth led to moving the ice cream–making operations into a separate plant downtown at 602 Payne (later North) Street. It was eventually torn down to make room for the ill-fated AutoWorld. While McDonald expanded its physical facilities in Flint, the business also acquired other dairies around the state to expand its marketing area.

William McDonald retired as general manager in 1962. In 1976, he donated his 120-acre farm on Perry Road to the Grand Blanc Community Foundation. Now a new subdivision, called Meadows at McDonald Farms, there are still two barns on the property, including one with a sign saying "W.A. McDonald." William McDonald died in 1979 at age eighty-nine.

The company acquired additional dairies and a convenience store chain in the early 1970s, but it developed financial problems leading to a $1.82 million loss in 1976 despite record sales. To avoid bankruptcy, the dairy farmer member-owners sold the company to the Michigan Milk Producers Association in 1979, thus keeping a market for their milk.

On November 1986, the MMPA sold the Flint dairy to Grand Rapids–based Country Fresh Dairy. By 2000, Country Fresh had dropped the McDonald brand, despite the McDonald sign still on the dairy. That changed in 2002, when the McDonald sign was replaced by a Country Fresh sign. The old sign was donated to the Sloan Museum and is currently in storage. Country Fresh closed the former McDonald Dairy plant in 2009, with production shifted to plants in Grand Rapids and Livonia.

Just like you'd make
it-with fresh fruit
and nuts!

Tutti Frutti
ICE CREAM

FLAVOR OF THE MONTH

FIRST... in good taste!

Look For the Familiar
Cream and Red
Custom-Packed Carton

AT ALL McDONALD
ICE CREAM DEALERS

A 1952 McDonald Dairy ad in the Flint
Journal. *Courtesy of the Flint Public Library.*

In the mid-1930s, a dairy whose products were mainly sold to institutions was founded. I recall that in the old Northern High School cafeteria the milk was supplied by Creamline Dairy. It was originally co-owned by Robert K. Adams and Pierce Peltier. Creamline Dairy's original location was 1206 Kirk Avenue. A year or so later, Philip Miller bought Peltier's interest, and the following year, Miller bought out Adams's interest to become sole owner. For the rest of Creamline Dairy's history, it was owned by the Miller family. By 1939, it was located at the address it would occupy for the rest of its history: 3907 North Saginaw Street. It was a retail and wholesale dealer of milk and dairy products. Around 1969, Harold Miller took over the dairy. By 1983, Gust Miller had joined in, taking sole ownership by 1984. But its days were numbered. In the 1985 Polk city directory, it was called Miller's Dairy at the same North Saginaw address but no phone number listed. By the time the 1987 Polk directory was published, the dairy and the building were gone.

Around 1937, Verner Nelson took over the former Creamline Dairy space at 1206 Kirk to form Nelson Dairy, offering a full line of what he called the better grade dairy products. By 1942, it moved to 614 West Dayton Street and expanded three years later, dislocating the Flint Gospel Assembly Church next door at 606 West Dayton Street. From that point on, the dairy's address was 606 West Dayton Street. Nelson sold the dairy around 1947 to a company that operated several dairies, Pure Seal Dairy Inc., which offered milk and dairy products in paper containers. By 1952, the company had split into two entities: Pure Seal Dairy, still on West Dayton Street, and a new entity, Pure Seal Products, making ice cream at 1926 North Franklin Avenue. By 1959, Pure Seal Dairy Company had been sold, and it became a division of Dean Milk Company of Franklin Park, Illinois. Pure Seal also owned Dairy Queen at that time and kept the Franklin Avenue Ice Cream Plant, renamed it Dairy Queen Enterprises Inc. and supplied the franchised Dairy Queen ice cream stands. By 1964, the West Dayton Street dairy had been officially renamed Dean Foods Inc. It lasted through 1970. By 1971, the 606

West Dayton Street address was occupied jointly by Sunshine Food Stores and Allied Refrigeration. From 1972 to 1974, the Polk Directory showed 606 West Dayton serving as the London Farm Dairy warehouse, and the 1975 directory showed the location was occupied by the National Farmers Organization, which ended that building's life as a commercial dairy.

Finally, we look at Miller Road Dairy, which was located on acreage owned by Roswell Glass, who lived there. He and his three sons, Fred, Joseph and Maurice, ran the business. The dairy was founded in the mid-1960s as an extension of the Miller Road Restaurant at G-3341 Miller Road in Flint Township. By 1970, the dairy had absorbed the restaurant's space, with Fred Glass taking sole control. Family issues led the Glass family to liquidate the dairy and sell the land on February 13, 1978. After renovations, the former dairy became a U-Haul truck rental location, which it still is today.

14

James Hurley

Businessman and Humanitarian

The more than century-old Hurley Medical Center is a major hospital centrally located in Flint. The man behind the name was an English immigrant who settled in Flint and became a successful businessman.

James J. Hurley was born in London, England, on August 31, 1849. He began earning money for himself at age six by returning fruit baskets to dealers, for which he received a penny a piece. By age thirteen, he accumulated $400, which he used to start his own business selling fruit and merchandise. But at age twenty, business setbacks made him broke.

So, in 1871, he decided to immigrate to the United States and arrived in New York. He went straight to Michigan, arriving in Grand Blanc. He traveled to Flint by foot. By that winter, he had found work at a livery earning ten dollars per month.

In 1872, he partnered with William H. Fay to operate the Sherman House Hotel on West Kearsley Street. Hurley met dining room girl Mary Flynn there, whom he married. Sherman House was destroyed by fire in 1879. Hurley then purchased the Flint Soap Works, which was located on what is now Grand Traverse near the Flint River. In 1885, Hurley opened a wood and coal yard. The People's Electric Light and Power Company was also founded that year, with Hurley as president. That company was later reorganized into the Flint Light and Power Company, with Hurley serving as vice president. Hurley was also a director of the Union Savings Bank.

On January 12, 1900, Mary died at her home after an unspecified acute illness that began when she complained about a headache and lasted ten

days. She was just forty-three. The *Wolverine Citizen* reported her death in the following day's issue.

In the fall of 1904, Hurley became ill with Bright's disease, a kidney disease known as nephritis today. He was initially determined to continue his work, but he required continual care from two nurses that December. Hurley died at 5:15 a.m. on April 4, 1905, of heart failure at age fifty-five. The April 4 issue of the *Flint Daily Journal* reported Hurley's death on the front page and mentioned that—even though Hurley's will was not yet filed for probate—his will bequeathed $500 to every church in the city regardless of faith and ten to twelve acres of land on a high elevation west of downtown and $25,000 for the construction of a general hospital in the city.

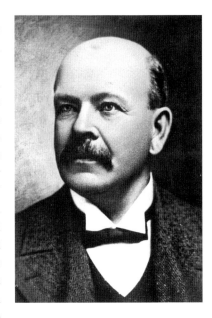

James J. Hurley. *From Inside Report, Hurley Medical Center, winter 1988.*

Two days later, Hurley's funeral was held at St. Michael Catholic Church. Officiated by the Revered Timothy J. Murphy, the ceremony was heavily attended, and there were many floral tributes. Quoting the *Flint Daily Journal's* article about the funeral, Father Murphy "preached a fine discourse in which he paid high tribute to the generosity and other elements that were conspicuous in the sturdy character of the deceased." Hurley was buried at what is now Old Calvary Cemetery on Ballenger Highway at the edge of a ravine next to his wife. The Hurleys had no children. Besides the Flynn in-laws, the only blood relative surviving James Hurley was a niece in London, England.

Besides bequests to family members, associates and employees, Hurley also gave $500 toward the construction of a new Elks lodge and donated his home at the end of Stockton Street north of West Third Street, which he dubbed "Mary's House," to the Little Sisters of the Poor of Detroit. That organization was unable to utilize the house, so it was sold to Edward D. Black and continued to serve as a private residence for several decades, until it was converted to a three-unit apartment in the 1950s and later torn down.

Hurley's legacy with his generous bequests benefitting the city was unusual in 1905, when most people had more provincial thoughts and did not have

the foresight to help and benefit future generations—which Hurley clearly had. He had genuine compassion for people that he displayed in his giving. He wanted to give something to the city that would benefit all people. This was a gift of gratitude to the city and the people of the area who had dealt with him so generously.

Hurley Hospital officially opened on December 18, 1908, as the first "modern" hospital in the city, with forty beds, six bassinets and a staff of eight nurses. The hospital grew with the city to become what is now Hurley Medical Center, which still follows James Hurley's original vision to provide care to all citizens regardless of ability to pay. In fiscal year 2014, Hurley provided $80 million in uncompensated and charity care.

After more than one hundred years, the final resting place of Mary and James Hurley at Old Calvary Cemetery—the oldest surviving cemetery in the immediate Flint area—showed obvious signs of erosion over the decades. Mary's grave lost more soil to the adjacent ravine and both individual markers have shifted due to the eroding soil. The large stone bearing J.J. Hurley's name had small broken stones used as shims below its base. The Hurley grave site sloped downward to such a degree that visitors needed to be careful, despite a chain-link fence at the edge of the ravine.

The management of New/Old Calvary Cemetery and the Roman Catholic Diocese of Lansing's Office of Cemeteries had been aware of the

Postcard of the original Hurley Hospital. *Gary Flinn.*

sinking of the Hurleys' graves for more than a decade back in 2008. After four additional years of planning, a retaining wall was built along the ravine in 2012. The Hurley plots were leveled and re-landscaped, and new concrete pads were poured for the Hurley markers. The restoration of the Hurley graves was a complicated process that required getting materials and heavy equipment into the ravine while being respectful of the deceased. The only easy access is at the end of Nolen Drive at the Mott Park Golf Course. The retaining wall was built using precast concrete sections. The end result was a beautiful restoration of the plots of James and Mary Hurley at historic Old Calvary Cemetery.

Lloyd Copeman

Flint's Most Prolific Inventor

The most prolific inventor to call Flint his home was Lloyd Copeman, who invented, among other things, the electric stove, the flexible ice cube tray and the automatic toaster. Copeman was born on December 28, 1881, and raised on a farm in Hadley Township, twenty miles east of Flint. He attended what is now Michigan State and studied engineering but was expelled. When he was later offered an honorary degree, he refused to accept it.

His career began as a mechanist apprentice at Baldwin Locomotive Works before he began working at electric utility companies, starting with Philadelphia Edison and then moving on to Washington Electric of Spokane, Detroit Edison and Consumers Power. While in Washington State, he married his old school sweetheart Hazel Berger, who was also living there in 1904.

It was in 1906 while at Washington Electric that he invented his first significant product: a thermostat to warn when utility transformers were about to burn out. This proved to be a useful component for his electric stove as the controller of the stove's temperature. His first patent was granted in 1901 for an instrument for cauterizing wounds during surgery.

After returning to Michigan and settling in Flint, Copeman and twenty-two stockholders led by J. Dallas Dort founded the Copeman Electric Stove Company in 1912. While the first models looked like an old-fashioned wooden icebox, redesigns gave the stove a more modern appearance by moving the oven to waist height and making the burners more convenient

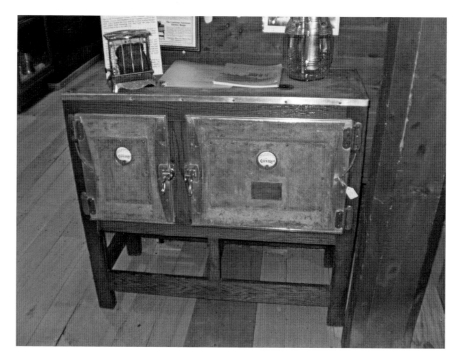

The Copeman electric stove with a Copeman toaster on top at the Hadley Mill Museum. *Courtesy of Kent Copeman.*

for the homemaker. While Copeman was an innovative inventor, he admitted he lacked the marketing skills to promote his stoves. But he found someone—George Westinghouse III, president of Westinghouse Electric Corporation and son of the famed inventor—who had the marketing skills. So in 1917, the company was sold to Westinghouse, and the stove factory moved to Mansfield, Ohio.

The next significant invention was also destined for the kitchen: the self-turning toaster. The design was created in 1914, but Hazel began working on it using hairpins, so she got the patent. That design became obsolete when Toastmaster introduced the pop-up toaster in 1926.

After the sale of the stove company, Copeman was invited by Dort to join the Detroit Athletic Club, where he got to schmooze with other significant innovators, such as Thomas Edison, Henry Ford, the Fisher brothers and the Dodges.

By 1918, Copeman and Edwin W. Atwood co-founded the Copeman Laboratories Company in a part of an old Durant-Dort Carriage Company factory where Copeman continued to do his research. In 1928, Copeman

Lloyd Copeman demonstrating the flexibility of one of the ice cube trays he invented. *Courtesy of Kent Copeman.*

had his inspiration for his most lucrative invention. While he was collecting maple sap, he noticed that slush and ice was easily flaking off his rubber boots instead of adhering to them. After recalling this experience over lunch with his patent attorney at the Detroit Athletic Club, he experimented with his idea at the DAC using rubber cups and asked DAC staffers to fill them with water and freeze them. After lunch, he found it was easy to remove the resulting ice from the cups. He designed three types of ice cube trays. One made completely of rubber, a rubber coated metal tray and one with removable cube holders. The patent was sold to General Motors, which at that time owned Frigidaire, and he earned $1 million in royalties.

He also patented developments that made improvements to refrigerators and freezers in the 1920s and 1930s.

Copeman Lubri-Caps—an automotive-oriented invention—were pre-filled grease cups for lubricating wheel bearings. A time-saver for mechanics, the Alemite Company bought the Lubri-Caps patent for $178,000. A flexible clothes line Copeman made using braided rubber surgical tubing called Flexo-Line was an aid for travelers who need to do laundry on the road. This product is still on the market. He saw a market for a garden rake cleaner so he formed a company that made a gadget to attach to the handle of a standard rake that pushed debris off the rake. Copeman was interested in wildlife, including birds. Around 1940, he formed Cope-Craft products, which offered mail-order birdhouses, feeders and suet cakes. He also developed die-cut products, such as wastebaskets of various shapes, a fly swatter and a berry box.

Besides Dort, Copeman also worked closely with Charles Stewart Mott.

Over the years, Copeman received over 650 patents, making him one of the most prolific inventors of the twentieth century. He kept on working on projects until he died on July 5, 1956, at age seventy-four, succumbing to

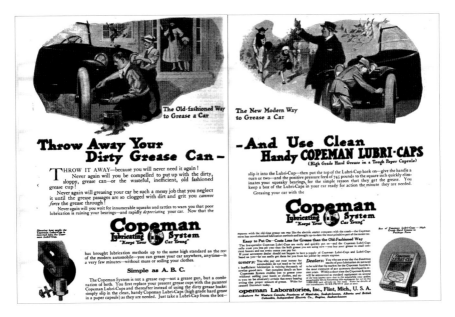

Vintage two-page Copeman Lubri-Caps ad from the March 16, 1918 issue of the *Literary Digest. Courtesy of Kent Copeman.*

cancer and diabetes. He was awarded a patent posthumously seven months later for a "moisture impervious container."

He and Hazel had a son and two daughters. One of his granddaughters is singer Linda Ronstadt. His grandson Kent Copeman is president of the Hadley Township Historical Society in Lapeer County, which operates the Hadley Mill Museum containing Lloyd Copeman memorabilia, including his electric stove and toaster.

As for the stove company he founded, Westinghouse Electric sold its major appliance operations to White Consolidated Industries in 1975 and began marketing White-Westinghouse appliances. White Consolidated Industries bought Frigidaire from GM in 1979. White Consolidated Industries was, in turn, acquired by the Swedish appliance maker Electrolux in 1986. So think about it. That White-Westinghouse, Electrolux, Tappan or Frigidaire electric stove in your kitchen has its roots in Flint. Electrolux also makes Kenmore stoves for Sears. A vintage Copeman electric stove is on display at the Sloan Museum.

Thanks to Kent Copeman. Visit the official Lloyd Copeman website at LloydCopeman.com

When Marxism Came to Flint

That's Marxism as in Groucho, Harpo, Chico, Zeppo and Gummo. Before radio and talking movies became the prime sources of entertainment in the United States, the primary entertainment medium was a live variety show called vaudeville in which itinerant performers traveled around the country to provide family entertainment in towns large and small. One of these groups that performed around the country during the 1910s were the Marx Brothers, who were originally a singing act and evolved into a musical comedy act.

Flint's first theater developed for vaudeville was the Bijou, which was located on East First Street between Harrison Street and Brush Alley. It was opened in 1905 by Colonel Walter S. Butterfield, who owned other vaudeville theaters around the state.

While the Marx Brothers appeared in Flint a few times, I'll focus on three of their stops, beginning with their appearances at the Bijou from Sunday, February 2 through Wednesday, February 5, 1913. The show they presented was the musical comedy *Mr. Green's Reception*. The review for these performances was very positive:

> *It is generally conceded by those who have witnessed the Marx Brothers' musical production at the Bijou during the first half of this week that they have spared neither effort nor expense in making their present season's musical comedy offering one of the smartest and brightest tabloids in vaudeville. Their chorus of juveniles is really the best singing and dancing*

chorus to tread a local stage in a long time and the return of the Marx Brothers in a similarly musical tabloid will be awaited with interest by Flint theatergoers.

In another review during the same engagement, praise was given to Harpo (real name Arthur), who was called Artie in the following: "As a harp soloist Artie Marx instantly won the hearts of the Bijou audiences yesterday. His rag medley on the harp was truly a wonderful musical novelty."

The Marx Brothers were managed by their mother, Minnie. They had an uncle (Minnie's brother) who was a top-billed vaudeville performer, Al Shean, of the comic duo Gallagher and Shean.

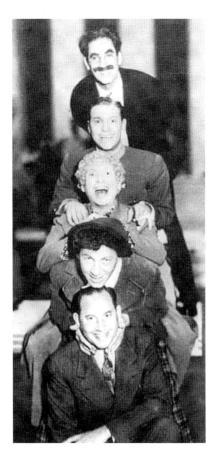

Groucho, Zeppo, Harpo, Chico and Gummo Marx. *Courtesy of* Broadside.

They returned the following year to the Bijou on Thursday through Saturday, March 12, 13 and 14, 1914, with a repeat presentation of *Mr. Green's Reception* preceded by their earlier act, *Fun in Hi Skule*. The way the acts were structured, *Fun in Hi Skule*, as the name implied, was a schoolroom act the Marxes started performing in 1910 and *Mr. Green's Reception* was a twenty-year reunion first staged in 1912. A review based on their previous engagement in Kalamazoo stated, "The show is nearly the same as last year, only it moves easier and many new songs have been added. The Marx brothers are as amusing as ever and there is not an attraction on the road that furnished a more gingery performance." The actual review at the Bijou stated, "There is a trace of a plot in the tabloid which serves merely to hold the act together. The rest of it is all music and girls, with no partiality shown in either direction. The comedy is inclined to be of the slapstick variety at times, but for the most part it is the provoker of plenty of laughter. The songs are new and catchy."

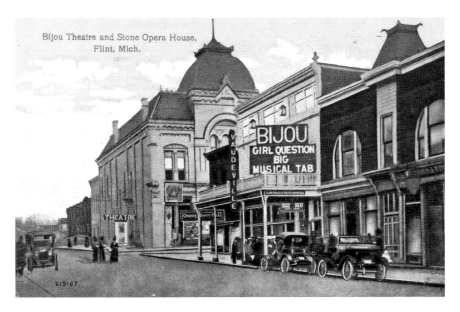

Vintage postcard of the two theaters where the Marx Brothers played. The Bijou Theatre in the foreground and Stone's Opera House (later the Majestic Theatre) in the background. *Gary Flinn.*

They returned to Flint on Thursday through Saturday, September 1, 2 and 3, 1915, at the larger Majestic Theatre. The Majestic was built in 1883—originally called the Music Hall—to host operas and plays. After Oren Stone acquired it around 1894, it was renamed Stone's Opera House. It continued to offer operas and plays until 1913, when Colonel Butterfield leased it. After renovations, it was renamed the Majestic and offered vaudeville.

The Marx Brothers' show at the Majestic was *Home Again*. Their Flint engagement was significant in that all five Marx Brothers appeared on stage in what is believed to be the only time. At that time, the act consisted of Groucho, Chico, Harpo and Gummo. But in this engagement, fourteen-year-old Zeppo joined in to make it five Marx Brothers.

Home Again was also significant in that during the tour, Harpo decided to stop talking. The script gave him just a small amount of dialog, which he objected to. He also took personally a review in which his pantomime was praised, but his dialog wasn't. So Harpo performed mute from that time onward. That reason is less entertaining than Groucho's reason. He posited that after a bad experience at a coal town's theater in Illinois in which they barely made it to the train to the next tour stop, Harpo

yelled, "Here's hoping your lousy theater burns down" and found out the following morning that it did, so they decided it was too dangerous for Harpo to talk.

The review of the Flint stop for *Home Again* was also glowing. At the time, they were still using their real names instead of their more familiar nicknames:

> *The Four Marx Brothers, Julius* [Groucho], *Milton* [Gummo], *Leonard* [Chico] *and Arthur* [Harpo], *who have on many previous occasions delighted Flint patrons of vaudeville, opened another three-day engagement at the Majestic yesterday. For this occasion however, there is a fifth Marx brother in the company Master Herbert Marx* [Zeppo] *a lad of about 14 who gives promise of becoming as much of a favorite as the rest of the family. Master Herbert added some four or five songs on the rest of the program last night in a manner which left no doubt as to his future.*
>
> *"Home Again" is the title of the new Marx vehicle and from the greeting they received when the audience recognized the old favorite of "School Days," it seemed just like a home coming. "Home Again" is a musical comedy with the accent on the music. It is doubtful if a better singing company has ever been heard here in a production of this sort. There is more to the piece than vocal music too, for Leonard Marx offers some new stunts at the piano while brother Arthur draws both music and laughter from his harp. Julius Marx still sings his German comedy song: "Mr. Stein" while Milton has added countless dance steps to his already large collection. Every member of the family has some accomplishment which is mended to the success of the musical comedy.*

Gummo left the act to enter military service during World War I, and Zeppo replaced him. Their success had gone to their heads, which alienated vaudeville boss E.F. Albee, who blacklisted them. So they turned to the Broadway stage in 1924 and were very successful with their three Broadway shows. When the movies learned to talk, they were among the stage performers lured to Hollywood, where they made their film debut in the 1929 adaptation of their Broadway show *The Cocoanuts*.

As to the theaters they played in, the Bijou was renovated a few times and renamed the Garden in 1915, adding movies. It dropped vaudeville and switched to talking movies using both Vitaphone and Movietone sound in 1929. The Garden was torn down in 1939 to make way for the

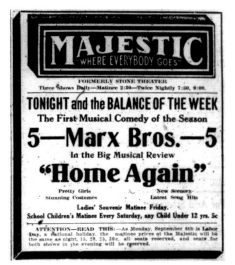

A 1915 *Flint Journal* ad for the only known appearance of all five Marx Brothers on stage at the Majestic Theatre. *Courtesy of the Flint Public Library.*

new Garden Theatre. It closed in 1957 and was torn down in 1966 to make way for Genesee Towers. (See chapter 32.) The Majestic also added movies to go along with its stage shows. As larger, grander theaters such as the Palace (see chapter 19) were built for vaudeville and motion pictures, the Majestic was reduced to presenting roadshow acts until it went dark in 1921. It was torn down on March 1923 to make way for the new home of the *Flint Journal*, and the site today is Michigan State University's College of Human Medicine.

This piece utilized material from the books Monkey Business *by Simon Louvish and* Picture Palaces & Movie Houses *from the Genesee County Historical Society as well as old* Flint Daily Journal *articles from 1913, 1914, 1915, 1921 and 1923.*

The Former Flint City Cemetery Site and Avondale Cemetery's Pioneer's Row

For this story, we take you to an old cemetery that does not exist anymore. But several of its stones and bones were moved to a nearby cemetery in 1958. The cemetery in question is the old City Cemetery, which was located along southbound Chavez Drive where the local Social Security office and eastbound Longway Boulevard meet at the intersection with Avon Street, which is now W.H. Schwartz Drive, where the Behn & Behn Law Firm is now. The cemetery was established in 1842, when Flint was still a village.

By the 1950s, it was overgrown with weeds and trash, making it look more like a dump than a cemetery. So in the early 1950s, the city decided to redevelop the property. Beginning in 1952, the city moved 1,199 remains, including 925 unknowns, to the new City Cemetery at Linden Road and Pasadena Avenue. Some bodies exhumed were buried in buckskins; others were buried on top of each other. Remains reclaimed by family members were reburied in other cemeteries.

In 1958, what was thought to be the last of the remains, as well as 122 ancient and not-so-ancient markers, were moved to an unplatted section of Avondale Cemetery under the supervision of funeral director Leroy Zelley. The old cemetery property was sold to Albert J. Koerts—who owned the adjacent Koerts Glass and Paint—for commercial development and to expand the business.

By 1974, I-475 construction and the dividing of Longway Boulevard at I-475, which bisected the property, had forced Koerts Glass and Paint (which closed in 2007) to move to the former East Side Buick dealership on

Portion of an 1898 map showing the locations of the City Cemetery and Avondale Cemetery on what was then Richfield Road. *Courtesy of the Library of Congress.*

Dort Highway where the CARite used car dealership and service center is now located.

When the Holiday Inn Express was built in the mid-1980s, more than two dozen more remains were found and reburied at the new City Cemetery.

The section in the rear of Avondale where the gravestones were moved is called Pioneer's Row or Avenue. The stones were arranged in two rows close together in a way that the stones and bones may not be buried together.

There are several tombstones that predate the city's incorporation in 1855. The earliest found was for Mary Lyons, who died on September 9, 1839, at age fifty-six. Her husband, Isaac, died on September 18, 1842, at age sixty-three. They share a common obelisk marker. Others included Wealthy R. Griswold, who died on January 18, 1849, and Solomon Hopkins, who died on July 25, 1850. There may be others, but the soft marble tombstones have become unreadable now.

Behind a row of Civil War veterans' markers bunched together is a Civil War casualty memorialized with a broken obelisk marker, with the top two parts laying on the ground. One side of the standing base reads that he was mortally wounded at Mechanicsville, near Richmond, Virginia, on May 28, 1864, and the other side says Marvin J. Eldridge died in the hospital in Washington, D.C., on June 1, 1864.

Portion of a vintage map showing the former City Cemetery site and Avondale Cemetery on what was then Lewis Street. *Courtesy of the Flint Public Library.*

The tersest marker found simply read "Baby age two days." The newest stone found was for Clara B. Rising, who died on September 2, 1940. One mystery stone belongs to Annette Brown, who was born in 1844 but whose death remains a mystery, as the stone was left unfinished reading 19__, as if to imply that she is now more than 175 years old.

The most interesting and expressive tombstone belonged to a young Irish immigrant, whose stone reads, "Sacred to the Memory of Joseph Reighley, a native of Dublin in Ireland. A resident of some time of this village, he departed this life on the 4th February 1850 in the 38th year of his age. This stone is erected by his disconsolate [rendered on two lines as "disconso late"] widow as a tribute of respect to his memory." That marker is shown in this writer's book *Remembering Flint, Michigan.*

Finding out more about him, his similarly worded obituary appeared in the March 16, 1850 issue of the *Genesee Whig*, which added:

Dominus vobiscum et cum spiritu tuo. [The Lord be with you, and with thy spirit.] *A man of high moral character, of strict truth, and impartial justice. A kind and affectionate husband. An obliging neighbor. A sincere friend. Charitable, and humane to the needy. A true and believing Christian. Resting his hopes in a joyful resurrection through the merits and atonement of his blessed redeemer. He has left a disconsolate widow to deplore his death, who, from being a helpless foreigner, had no one before now to pen these obituary remarks, and save her the painful effort of doing only justice to the memory of her dear departed husband.*

There is a story among local historians that Koerts, who paid for the moving of the remains and stones, ran out of money to move the remains, so only the tombstones were moved, implying that there are still Flint pioneers buried in the parking lot of the Social Security office or in the law firm office's parking lot. Koerts was killed in an automobile accident in 1969. Pioneer's Row inside Avondale Cemetery with its old markers close together is a spooky place when Halloween comes around.

The Executive Homes on East Kearsley Street

When Charles Stewart Mott's Applewood estate was being built on what was then the edge of town on East Kearsley Street in 1916, that street east of downtown served as home for many notable executives.

For example, George C. Willson—at 422 East Kearsley Street—was a banker and served as a director and chairman of the Genesee County Savings Bank, which evolved into Genesee Merchants Bank and Trust Company through the merger with Merchants & Mechanics Bank. Willson's mother was a daughter of local lumber baron and Michigan governor Henry H. Crapo. The home he grew up in is now Willson Park on the University of Michigan–Flint downtown campus.

Charles Stewart Mott lived across the street at 423 East Kearsley. When he moved into Applewood, Albert Champion moved into that house. Champion founded two spark plug companies. He was a bicycle racer who founded the Albert Champion Company in Boston in 1905 in partnership with the Stranahan brothers. By 1907, they were manufacturing spark plugs. In 1908, Billy Durant persuaded Champion to move to Flint to establish the Champion Ignition Company. The Stranahans filed a lawsuit over the Champion name, which led to a settlement in 1922 in which the Champion Ignition Company was renamed the AC Spark Plug Company, utilizing Champion's initials.

At the time J. Bradford Pengelly lived at 412 East Kearsley, he was Reverend Pengelly, rector of St. Paul's Episcopal Church. He later changed careers and became a real estate developer. For example, he led the group of developers

Vintage postcard of East Kearsley Street. *Gary Flinn.*

that built the Capitol Theatre. Behind that theater building was a former Paterson factory building that he converted into an office building called the Pengelly Building, where he established his office. It served as the home for several labor unions and the base of operations for the 1936–37 Flint sit-down strike. The aging building was torn down in 1946. He also dabbled in politics as an unsuccessful candidate for Congress and served as a city commissioner. Pengelly was caught up in a bribery scandal in 1932, but he was eventually cleared of charges—not before he was forced into bankruptcy. During the Great Depression, he lost the Pengelly Building in a foreclosure. He moved away and resumed his ecclesiastical career. Where 412 East Kearsley once stood is the University of Michigan–Flint downtown campus.

Walter P. Chrysler—who led the Buick Motor division of General Motors in 1917—lived at 514 East Kearsley. Chrysler left GM when his contract with GM expired in 1919. In 1921, Chrysler acquired controlling interest in the Maxwell Motor Company, which became Chrysler Corporation. After Chrysler moved away, Dodge dealer Dallas Winslow moved in. Winslow tried to save the ailing Paterson company, but he was unsuccessful. Later serving as home to an architect, it was gone by 1972.

Horace C. Spencer lived at 517 East Kearsley Street. He was a banker who got his start in the local hardware business. He held executive positions with Genesee County Savings Bank and at Citizens Commercial & Savings

Reverend J. Bradford Pengelly, who would later change careers and be a real estate developer. *From the book* An Account of Flint and Genesee County from Their Organization, *edited by William V. Smith, published in 1924.*

Bank. That address would become the King's Daughters & Sons Home; as with the neighboring homes, it fell victim to the construction of I-475.

James G. Mallery lived at 527 East Kearsley. He owned the Flint Buggy Company. His son Harvey also worked at the buggy company. Harvey later became a vice president and comptroller at Buick. He moved into the house after his father's death.

Arthur G. Bishop and his son R. Spencer Bishop lived across what was then Richfield Road (later Lewis Street and even later Chavez Drive). The younger Bishop lived at 528 Kearsley and the elder lived at 606 Kearsley. Both led Genesee County Savings Bank, and Arthur G. Bishop donated land for the development of Bishop Airport.

Harry Winegarden lived at 621 East Kearsley. The Russian immigrant co-founded the New Orleans Fruit House, which was a successful fruit and later meat market. Harry and his brother Hyman added another business venture: Winegarden Furniture. He would become a director at Citizens Bank. He co-founded the local reform synagogue, Temple Beth El.

Robert J. Whaley was another banker who led Citizens Bank. The loans he approved led to the formation of General Motors. That home at 624 East Kearsley is still standing, and it is now the Whaley Historic House Museum.

Edward T. Strong lived at 703 East Kearsley. He was a Buick executive who would go on to become president of Buick. He later built and moved into a large castle-like Mediterranean Revival home in the Woodcroft Estates subdivision south of Miller Road, where grander executive homes were built beginning in 1925. Built in 1930 and later owned by members of the Hamady family of local grocery fame, the home on Parkside Drive was recently restored by its current owners. The Kearsley Street home had disappeared by the time Walker School (now the Walker Place building) was being built.

Vintage map showing East Kearsley Street. Note that J. Dallas Dort owned the land that Charles Stewart Mott's Applewood estate would later be built on. *Courtesy of the Flint Public Library.*

Charles T. Bridgman lived at 814 East Kearsley. He was the Bridgman half of the Smith-Bridgman department store downtown, which became Flint's largest department store in its peak years. Bridgman was the first president of the Union Trust & Savings Bank, which was located downtown where the Mott Foundation Building now stands. The Kearsley Manor apartment building now stands where the Bridgman house once stood.

Mathew Davison was also an executive of Union Trust & Savings Bank. He served as the bank's cashier for many years and ultimately served as chairman of the board. He also served as Flint's mayor in 1885. He lived at 817 East Kearsley, where Walker Place now stands.

John G. Windiate lived at 902 East Kearsley. He was a real estate developer and a partner in the Windiate-Pierce-Davison real estate firm with John L. Pierce and Arthur M. Davison. The firm developed several subdivisions in Flint. Townhouses were built where Windiate lived.

At 1025 East Kearsley stood a large, stately house where carriage and auto maker J. Dallas Dort lived. After he died, his widow, Marcia, continued to live in that home until she donated it in 1958 for use as a music school, which developed into the Flint Institute of Music. Originally called the Dort Music Building, expansion began in 1970 in the old Dort home. During construction, the former home was destroyed by fire. Today, the expanded facility housing the Flint Institute of Music is called the J. Dallas Dort Music Center and houses the Flint School of Performing Arts and the Flint Symphony Orchestra.

Finally, where Kearsley Street now ends at Robert T. Longway Boulevard is Mott's Applewood Estate. After Charles Stewart Mott's widow, Ruth Mott, died in 2012, the Ruth Mott Foundation took over Applewood, which began offering regularly scheduled tours in 2016 to mark Applewood's centennial. Applewood also offers scheduled events and exhibits.

The addresses and residents were researched utilizing volumes of Flint city directories published by R.L. Polk & Company.

19

Playing the Palace

It is the year 1916 in the growing city of Flint. W.S. Butterfield, the Battle Creek–based owner of the Bijou and Majestic Theatres in Flint along with theaters in Battle Creek, Kalamazoo, Jackson, Ann Arbor, Lansing, Saginaw and Bay City, announced plans for a third theater in Flint.

The Palace Theatre seated 1,450 people at the corner of Kearsley and Harrison Streets. The estimated cost of construction was between $75,000 to $80,000. The theater was equipped with a proper-sized stage so any production could be staged and have a seventy-foot rigging loft. It was designed by Chicago architect John Eberson to resemble a Roman garden under an Italian sky with twinkling stars. This was an early example of the atmospheric theater that Eberson would perfect over the next few years. A decade later, the form reached its zenith with the Capitol Theatre—which Eberson designed—two blocks south of the Palace along Harrison Street.

It opened on August 30, 1917, with a five-act bill of live vaudeville entertainment. The dedication opening that night played to two capacity audiences totaling nearly five thousand patrons. Before the live acts, a six-piece orchestra played six short musical numbers, and a filmed travelogue with scenes of Norway was shown. The first live performers were the bouncing ball novelty act of the Alexander Brothers and Evelyn. They were followed by a singing duo who called themselves "A Couple of Nifties," Foley & O'Neil. Then there was a musical comedy called *The Smart Shop* starring Ed W. Rowland and Lorin J. Howard with Harry Kessler, Josephine Taylor and a chorus of six young women. They were followed by comedian Al Shayne,

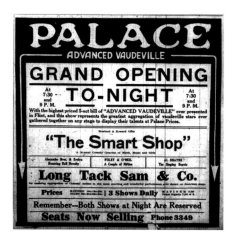

A 1917 grand opening ad in the *Flint Journal* for the Palace Theatre. *Courtesy of the Flint Public Library.*

who called himself "The Singing Beauty." The headliners were a Chinese troupe, Long Tack Sam & Company, consisting of jugglers, magicians, musicians, contortionists and acrobats. A Pathé newsreel was made of the dedication, placed in a metal box and sealed in the cornerstone.

Over the years, notable performers who appeared on the Palace stage included Boris Karloff, Ethel Barrymore, Helen Hayes and Kay Francis. When the movies learned to talk in 1927, the Palace continued to offer live vaudeville and silent movies until May 1929. After a one-night-only roadshow appearance by noted stage actor, dramatist and producer William Hodge on May 25, 1929, the theater was closed for a summer of refurbishing and retrofitting to wire the theater for sound and offer talkies. It had its grand re-opening on September 8, 1929, and featured talking movies while continuing to offer vaudeville acts from the RKO circuit. The first talking movie shown at the Palace was *The Sophomore*, starring Eddie Quilan, Sally O'Neil and Jeanette Loff. There was also a Paramount newsreel and three live vaudeville acts: Britt Wood, who called himself "the boob and his harmonica," the singing and dancing group the Gills and Clemens Belling with his Jolly Family, a European novelty act.

With the Great Depression in full force in 1931, the Palace closed temporarily after the final shows on June 6, 1931, with the feature *Girls Demand Excitement*, starring John Wayne, Virginia Cherrill and Marguerite Churchill, preceded by selected shorts. It reopened on February 15, 1934, with *Cat's Paw* starring Harold Lloyd preceded by such shorts as a Betty Boop cartoon, a Terrytoon, a comedy short and a Fox Movietone newsreel.

While vaudeville faded away, the live acts continued at the Palace into the 1950s, including the popular Cowboy Jamboree. But the ornate theater had started to look old-fashioned by 1950, so in May, construction began to renovate the Palace inside and out. After the last showing of *The Good Humor Man* starring Jack Carson on July 4, the theater was closed for a couple of months to complete the renovations.

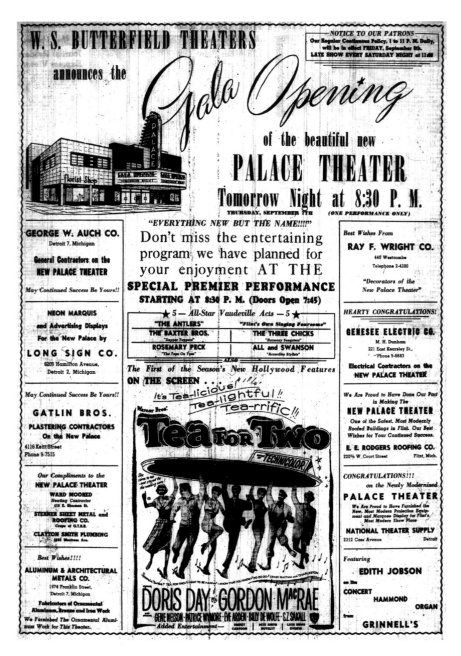

A 1950 grand re-opening ad in the *Flint Journal* for the modernized Palace Theatre. *Courtesy of the Flint Public Library.*

The renovated theater reopened on September 7, 1950, with a special show featuring five local live acts, echoing the theater's storied history of offering vaudeville, with toe-tapper Rosemary Peck, accordion players Stephen All and Joyce Swanson, teenage singers the Three Chicks, tap dancers the McLaughlin Sisters and barbershop singing quartet the Antlers. The feature film was *Tea for Two*, starring Doris Day and Gordon MacRae. The renovated theater itself was the real star of the show. The noted architectural firm of C. Howard Crane and Associates, which designed many landmark theaters over the years, such as the Fox Theatre in Detroit, removed all traces of the theater's original design to make way for the new art deco motif. Outside, the mansard roof was removed, and the front was finished off with colorful red and yellow porcelain enamel tiles. Three thousand light bulbs lit up the new all-glass-front marquee and thirty-foot vertical sign. The theater is prominent on this book's back cover. Inside, the outer lobby was enlarged by removing a storefront to make way for a new refreshment stand. The foyer was enlarged by removing an expendable stairway and finished in walnut. The auditorium lost all of its ornamentation as well as the side boxes and gained modern recessed lighting with decorations by two local Flint men, Ray Wright and artist Elmer Peterson, who provided the attractive murals. Capacity was reduced to 1,350 seats, and several hundred latecomers had to be turned away.

In the 1970s, the Palace began to show more films catering to Flint's African American community, such as the pioneering 1971 film that began the decade's black cinema genre, Melvin Van Peebles's *Sweet Sweetback's Baadasssss Song*, which played at the Palace. The surprising success of *Sweet Sweetback* led the Hollywood studios to begin producing films catering to black audiences to try and duplicate that film's success, and it started a cycle of kung fu and black exploitation films playing at the Palace.

But with the development of the University of Michigan–Flint downtown campus, condemnation proceedings began on July 1975 by the Flint City Council due to the theater's complicated ownership. The theater closed with the double bill of the 1973 film *The Mack* starring Richard Pryor and the 1974 film *Foxy Brown* starring Pam Grier, with *Foxy Brown* the final film shown on Sunday, January 25, 1976.

When the city bought the theater and turned it over to the university, there were calls for the university to utilize the theater as part of the campus. It was determined that it would cost at least $900,000 to renovate the Palace and bring the sixty-year-old theater up to code. Besides, they did not anticipate a need for an assembly hall as large as the Palace. When the demolition

company stripped the theater of salvageable material, it was discovered that the metal box from the cornerstone—which was removed just before renovations began in 1950 and stored in the theater's stage—was missing. It was believed that the newsreel in the box, which was filmed on unstable nitrate film, was unlikely to survive.

Demolition of the Palace Theatre began on February 11, 1977. After demolition was completed, the site was landscaped. Today, at the corner of Kearsley and Harrison is a University of Michigan–Flint sign as well as a diagonal sidewalk.

Flint Northern High School

Home of the State Champs

F lint grew by leaps and bounds in the 1920s thanks to the booming automotive industry. The Flint Board of Education built a new Flint High School in 1922 to replace an aging high school. But its student body grew too large, necessitating the need for another high school.

Thus, in 1927, Northern High School was erected at the corner of McClellan Avenue and Buick Street on a twenty-one-acre campus with the extant Emerson Junior High School facing Pasadena Avenue. It opened in 1928, the same year Garfield Elementary School was built next to Northern High. As a result of the opening of Northern High School, Flint High School was renamed Central High School, and a sports rivalry began.

The most famous rivalry was the annual Thanksgiving Day football game at Atwood Stadium, which was held from 1928 to 1976. The first game was played at Central's field and the second on Northern's field, before Atwood Stadium opened in 1930. The Thanksgiving tradition ended when the Michigan High School Athletic Association began statewide tournament play to determine the state high school champions. Out of the forty-nine games played on Thanksgiving, Northern won twenty-eight of them. Northern's athletic teams were first called the Eskimos before they became the Vikings.

The sport in which Northern dominated was men's basketball. Northern's men's basketball teams won the Class A state championship nine times: in 1933, 1936, 1939, 1940, 1947, 1971, 1972, 1978 and 1995. I recall when Northern won in 1971 when I was a sophomore there and Bill Freider was

Vintage Northern High School postcard. *Gary Flinn.*

coach. Freider would go on to coach the University of Michigan's and Arizona State's men's basketball team in a career that lasted thirty-two years. Northern was also a powerhouse in girls' basketball and in track and field.

Northern High School was added onto four times. First, for the school's twenty-fifth anniversary, the Wildanger Field House was built in 1953 along with a new auto shop, a new cafeteria and, where the old gym was located, new classrooms. Manley Pool was built adjacent to Wildanger Field House in 1955 as a gift from Charles Stewart Mott. On October 17, 1961, the Henry Cook Auditorium was dedicated.

The cafeteria was expanded in 1967 with a 2,500-square-foot addition that increased its capacity from 360 to 625, solving an overcrowding problem so 1,875 students could be housed in three shifts. The expanded cafeteria had a lower ceiling, ceramic tile walls replacing plastered walls, wood paneling, a new ventilation system, new floor covering, additional drinking fountains and a new dish conveyor system.

By 1967, all three schools on the twenty-one-acre campus were experiencing overcrowding. It was decided to move Northern High to a new campus just west of the city on Mackin Road in Flint Township next to Anderson Community School. This writer was among the last students at the old Northern on McClellan Street in 1971, as the faculty and staff packed up equipment for the move to the new school that fall. The boundaries were

redrawn and this writer transferred to Central for the junior and senior years. In the 1970–71 school year, 4,400 students were enrolled at Garfield Elementary, Emerson Junior High and Northern High.

The Flint Board of Education decided to assign kindergarten through fourth grade students to Garfield, grades five through seven as the newly dubbed Emerson Intermediate School and grades eight to nine at the relocated Emerson Junior High at the old Northern High location.

In 1976, as part of a desegregation program, Emerson Junior High returned to its original location as the former Northern High became a high school again—but not a high school in the usual sense. This school was patterned after private schools and academies that offered stronger education opportunities in a more disciplined environment called the Flint Academy. It operated from 1976 to 1988, when it was consolidated with Southwestern High School on the Southwestern campus and renamed Flint Southwestern Academy.

After Flint Academy closed, the Flint Board of Education put up the former Northern High School for sale, with hopes of converting the three-story building into apartments or a convalescent center. But with no prospective buyers—along with vandalism and high heating bills—it was decided to tear down the building. Demolition of the old Emerson Junior High, which was later used as the Flint Open School and finally as Mott Adult High School at Emerson Center, began in November 1988, with the old Northern High and the power plant serving both as well as the still-standing but closed Garfield School torn down by the spring of 1989.

Wildanger Field House and Manley Pool were not torn down at that time, as they were saved as a possible replacement for the aging Berston Field House. Kessel Food Markets had plans to build a supermarket on the old Northern/Emerson site, but labor opposition to the non-union grocer led to the abandonment of that project. In the end, the lack of meeting rooms and other amenities that Berston offered—as well as the high cost of renovations and repair of the old Northern Field House and pool—led to abandonment of that project. The site was purchased by the Greater Shiloh Baptist Church, which formed the Shiloh Community Development Corporation and planned a residential development. In 1997, both Wildanger Field House and Manley Pool were torn down to make way for the Shiloh Commons townhouse development. On the former site of the original Northern High School is a replacement power plant for Garfield School that incorporates architectural details salvaged from the demolished former high school.

Meanwhile, the new Northern High was still carrying on the proud traditions of the old school. But over time, declining enrollment at the Flint Community Schools eventually led to the closing of Flint Northern at the end of the 2012–13 school year. The initial plans were to convert the school into the Northern Alternative Academy, but it fell victim to budget cuts, leaving the new Northern campus abandoned and slowly deteriorating. Northwestern Community High School and what is now Flint Southwestern Classical Academy are Flint's remaining high schools.

Atwood Stadium

It began with a lumber mill founded by Newfane, New York native William Atwood in partnership with two partners in 1866 on Moon's Island, which was in the Flint River where Swartz Creek branched off. The mill closed in 1883.

Atwood had other local business interests and served as Flint mayor in 1882. Eventually, the former site of the mill became an unsightly dump. During World War I, there were calls by city leaders to build a park and armory on the lumber mill site. In 1917, the newly formed local Kiwanis Club organized a cleanup campaign of the lumber mill site, attracting five thousand volunteers. But the armory was built on Lewis Street instead, and a bond issue failed to pay for the park, so the dump returned.

Progress moved forward the following decade. In 1927, the northern side of Moon's Island was filled in, which eliminated the island. A former access road to the island off West Kearsley Street that now dead ends at the Flint River, where Swartz Creek branches off, is still called Island Street. In 1928, Edwin Atwood, William's son, donated the land and $5,000 to the city to allow for construction of a stadium to be called Atwood Stadium in memory of his father, who died in 1908.

The city raised $100,000 by selling Athletic Park to the Industrial Mutual Association to help pay for construction, and Atwood Stadium was formally dedicated on Saturday, June 8, 1929, in a lavish ceremony. The first major event at Atwood was held the following Monday: a series of boxing matches, including a championship fight.

Vintage postcard of Atwood Stadium when baseball games were also played there. *Gary Flinn.*

Another major event held at Atwood in 1929 was the Fifth National High School Band competition, when John Philip Sousa conducted more than three thousand young musicians to perform his "Stars and Stripes Forever." The free concert attracted around ten thousand spectators.

In 1936, Olympian Jesse Owens appeared at a baseball double-header and raced with members of the two semi-professional baseball teams between the games. Owens won both races.

Best known as a venue of high school football, it hosted the annual Thanksgiving Day high school football match between Flint Central High and Flint Northern High from 1930 through 1976. Atwood also hosted minor league baseball in the 1940s and early 1950s.

Lights were added in 1940 to allow night games to be played at Atwood Stadium at a cost of $10,000. The first name game was a minor league baseball game featuring the Flint Arrows, a Cleveland Indians farm team that played at Atwood in 1940 and 1941.

The Flint Arrows were revived in 1948 as part of a new six-team minor league, and the team was affiliated with the Detroit Tigers. The Tigers ended their affiliation with the Arrows in 1951, with the league folding in 1952.

President Franklin D. Roosevelt was at Atwood in 1936, and presidential candidate John F. Kennedy was there in 1960.

The largest crowd to attend an Atwood Stadium event was to see Flint Northern defeat Flint Central by a score of 20 to 13 at the 1950 Thanksgiving football game.

As part of Flint's centennial celebration in 1955, singer Dinah Shore, whose TV variety show was sponsored by Chevrolet, appeared at an event at Atwood Stadium called *Flintorama*. It was a huge pageant that told the story of Flint's one-hundred-year history through song and dance numbers. The event attracted more than 17,000 people.

In 1966, Atwood Stadium was extensively renovated. It received new ticket booths, new lighting, new sod and a larger two-story press box. In the renovation, the rear wall was removed and replaced by a fence with a rear entrance closer to the football field, which eliminated Atwood as a baseball stadium.

The sod failed in 1967, thus creating the infamous mud bowl that was the Central-Northern Thanksgiving game that year. This led to the installation of AstroTurf in 1968, paid for by the Mott Foundation with help from the city and the Flint Board of Education at a cost of $225,000. It was the first high school football venue to have AstroTurf installed. The artificial turf was replaced nine years later at a cost of $360,000.

Among the musical concerts held at Atwood Stadium over the years was a 1967 triple bill featuring the Blues Magoos, The Who and Herman's Hermits. Eddie Money played at Atwood in 1980, and Flint's own hit R&B group Ready for the World filled Atwood's stands in 1986.

But age and budget problems took their toll on Atwood. After the turf was deemed unsafe to play on, Atwood was closed in 1992. At that point, all Flint city high school football games were held at Houston Stadium on the Northwestern High School campus on Carpenter Road.

In 1995, the city completed $2.5 million in renovations, which included new turf and some new seating. But most of the stands and the façade were still in disrepair. In 1999, the Atwood Stadium Authority was created as the planning and fundraising organization to spearhead the restoration of the stadium.

But all that was done were small projects, such as improvements in lighting, parking and the scoreboard. In 2005, the Ruth Mott Foundation announced it would match up to nearly $340,000 of money raised, which encouraged additional donations. Starting that year, more work was performed at Atwood than in the previous decade. Among the improvements completed in 2006 were repairs to the iron gates, new lighting replicating the 1929 original, new concrete and vinyl covers

to protect the wooden bleachers. Seating on the stadium's west side was left unrepaired.

In 2007, the Charles Stewart Mott Foundation donated $250,000 to complete the restoration of seating. The grant restored the stadium's eleven thousand capacity.

Still on the drawing board were upgrades to the restrooms, locker rooms, west end concessions and new turf. But Flint's financial problems meant that further improvements to Atwood Stadium would take a backseat to more pressing issues. Meanwhile, nearby Kettering University was working on improving the neighborhood surrounding the campus, with special attention to University Avenue, which links Kettering to the University of Michigan–Flint campus. So, in 2013, the city and Kettering reached agreement to hand over ownership of Atwood to Kettering in exchange for reimbursement of $33,000 in electrical work at the stadium. Fundraising for the maintenance of and improvements to Atwood would continue.

In the meantime, Kettering has been acquiring properties near and around the stadium to improve the campus area. On January 2014, Kettering developed an ice skating rink to serve the community free of charge. The questionable condition of the artificial turf led officials to not play high school football games at Atwood for the 2014 season. Longtime stadium booster Genesee County circuit judge Duncan Beagle led fundraising efforts to make further repairs to Atwood as the old stadium authority evolved into the Friends of Atwood.

In 2015, the group spearheaded the installation of FieldTurf at a cost of more than $2 million. The field was also expanded so soccer and lacrosse could be played as well as football. Improvements were also made to drainage, lighting, the stadium's foundations, masonry, restrooms, concessions, locker rooms and seating. These improvements allowed Atwood to host 128 events in 2015. There are plans to relocate the stadium's parking lot—which is behind the stadium as of this writing—to other locations to allow the old parking lot along the Flint River to become parkland to complement the Flint River bicycle trail alongside the old parking lot.

In 2004, a book was published by the City of Flint and the Atwood Stadium Authority titled *Atwood Stadium—75 Years—1929–2004*.

Berston Field House

Incubator of Champions

The year is 1920. The city of Flint was trying to deal with its explosive growth. That year, noted Cambridge, Massachusetts city planner John Nolen (1869–1937) authored a report with recommendations on improving the city of Flint.

That same year, the widow and son of real estate developer Neil J. Berston Sr. (1856–1916) donated land at the corner of North Saginaw Street and what is now Pasadena Avenue to be used for the construction of a field house bearing his name. It was designed by Nolan's firm and is similar in layout to a Chicago field house at Fuller Park, still in use, that was shown in the 1920 report.

Berston Field House opened its doors in 1923. It is a mixed-use two-story building with a full basement and locker rooms flanked by two basketball courts, one of which can double as an auditorium with a stage. Outside are recreational facilities, including a ball field, two basketball courts and a tennis court. Behind the U-shaped facility is a multiuse hard surface that can be used as a recreation court or where seats can be set up to watch a game on the ball field. The exterior walls are of reinforced concrete and tile covered with stucco made with Portland cement. When it first opened, it included an outdoor swimming pool, a patio, meeting rooms and a public library.

In an era when many facilities were racially segregated, Berston became the first community center in Flint available for use by African Americans in the mid-1930s, but even then in the era of segregation, blacks were able to use certain Berston facilities, such as the library and pool, only on certain

Front entrance to Berston Field House. *Gary Flinn.*

days, a practice that ended in the 1950s. Berston became a magnet for neighborhood sports and recreation. One notable athlete who made use of Berston in those years was 1940s Northern High basketball standout Max Brandon. The former Forest Park on Dupont between Stewart and Pasadena was renamed Max Brandon Park in his honor

The basement of Berston has been noted for decades for its boxing facilities used for both training and bouts. It was the training ground for Golden Gloves boxers for many years. Among the notable boxers who trained at Berston were Chris Byrd and two-time Olympic gold medalist Claressa Shields. Berston's locker rooms are also located in the basement.

Even though the indoor basketball courts are not regulation size, they have yielded their share of notable cagers, including Flintstones Mateen Cleaves, Antonio Smith, Morris Peterson and Charlie Bell, who led Michigan State's basketball team to the NCAA national championship in 2000.

Many notable athletes who made use of Berston facilities over the years are depicted in a mural painted by Lavarne Ross and Al Foster in 2011. Among those depicted in the mural are football star and actor Terry Crews,

Heisman Trophy–winner Mark Ingram Jr. from the University of Alabama, basketball stars Glen Rice, Terry Furlow, Morrice Peterson, Justus Thigpen and Mateen Cleaves, boxers Joe and Chris Byrd, actor/boxer Tony Burton and former athlete and community activist Norm Bryant.

While Berston does show its ninety-plus years as you look around its facilities, volunteers do their part in keeping Berston maintained. But budget problems in recent years limited access to Berston. In fact, Berston was closed for a time in 2002 and 2003. But volunteers keep the facility in operation, led by volunteer director and Flint Third Ward city councilman Bryant Nolden.

Even though the swimming pool and library are long gone, Berston hosts other activities, such as the Berston Bicycle Club's rides on Saturdays from June to October launched by Angela Stamps. The club offers a nine-week course for children ages eleven to eighteen to learn how to properly ride a bicycle and tour different parts of the city. Stamps acquires used bikes, which are used to teach young riders. Funded by the Ruth Mott Foundation, it receives support from the Crim Fitness Foundation and Safe and Active Genesee for Everyone. Besides the regular bike tour, the club occasionally engages in other activities, such as a community clean-up and visioning workshop.

Berston is also home to the Creative Expressions Dance Studio, led by director Sheila Miller-Graham. Occupying Berston's second floor, it offers different types of dance instruction, including ballet, jazz, tap, hip hop and tumbling in its two dance studio rooms. Tap dancer Brinae Ali trained at Berston and now works in New York City singing and dancing on the Broadway stage.

The Chosen Few Arts Council, led by Omar Batson, offers a fine arts program for all ages at Berston.

To celebrate Berston's ninetieth anniversary in 2013, the facility hosted an open house. The event also celebrated the Chosen Few Arts Council's first anniversary. Outdoors, there was a stage set up with seating for live entertainment, including a music contest. There were also refreshments, vendors and bounce houses for the children. Indoors, the NAACP had a voter information table encouraging visitors of voting age to vote, understand the current voting laws and register to vote if they need to. They provided pamphlets provided by the Flint NAACP and the Michigan ACLU regarding the voting rights of Michigan residents.

The Berston Bicycle Club had its regular morning bicycle tour around the neighborhood. The Chosen Few Arts Council had registration for upcoming activities, such as arts and crafts, fundamentals of drawing, Music 101, basic

vocals and beginning drumming. There were also artists and face painting. Art was offered for sale in one basketball court, and gymnastics were held in the other basketball court. Boxers practiced in the freshly painted boxing room. It had championship belts hanging on the boxing ring and various displays showing the accomplishments of Claressa Shields. The upcoming dance season was promoted for those interested in dance lessons, with photo displays of dance students performing prominent in Berston's main lobby.

The outdoor basketball courts were in full use that day, although rain in the afternoon did hamper the outdoor activities. Looking around, you can still see the ghosts of the former pool on the north side of the building. The north façade had outlines of where the stairway leading from the basement locker rooms to the pool was as well as remnants of the pool's floor and retaining wall.

In 2014, a new nonprofit organization called the Friends of Berston was established to continue the storied history of the field house. In April 2016, the Friends of Berston was awarded a three-year grant by the Ruth Mott Foundation of $280,000 for programming and staffing at Berston. Genesee County commissioner Bryant Nolden was named the executive director of the Friends of Berston and Lynne Peterson the executive assistant.

With a bright future for Berston, it continues to be a vital anchor of the surrounding north side community, providing positive activities to keep Flint's youths and adults active and leading healthy productive lives.

Thanks to Bryant Nolden.

The Union Industrial Bank Scandal

The stock market crash of October 1929 led to losses totaling $50 billion and triggered the Great Depression. More than $3.5 million of those losses were attributed to "investments" by a dozen officials and tellers of the Union Industrial Bank playing the stock market using bank funds, unbeknownst to both the president of the bank, Grant J. Brown, and its chairman and largest stockholder, Charles Stewart Mott.

Founded in May 1929 through the merger of Union Trust and Savings Bank (founded in 1893) and Industrial Savings Bank (founded in 1909), Union Industrial Bank was headquartered in the former Industrial Savings Bank building (now part of Northbank Center). It had two other downtown offices and seven neighborhood branch offices. Its slogan was "The Bank of Personal Service" and boasted capital and surplus of $3 million and resources of more than $30 million.

The Roaring Twenties was a decade of great prosperity, and Flint was a great beneficiary of the good times, as it was enjoying explosive growth. But with the prosperity, there were temptations. As early as 1926, prior to the merger, individual Industrial Savings Bank employees were buying stocks worth as much as $8,000—which were bought but not paid for until they appreciated in value. It was not thought of as embezzling funds, but at the time it was thought to be a surefire proposition to make money.

By 1928, the dozen people involved in the individual stock trading realized what one another were doing and decided to pool their interests together, forming a group called the "league of gentlemen."

The hero of this story, Charles Stewart Mott. *Courtesy of the Library of Congress.*

The challenging part of the scheme was hiding the transactions from chairman Mott, president Brown and especially state auditors. Fortunately for the embezzlers, the state's staff of auditors at the time was limited in number, allowing for the secrecy of their questionable transactions. Mott, of course, was busy in Detroit as vice president and board member of General Motors. Complicating things for the twice-widowed fifty-three-year-old Mott was his romantic interest in the twenty-nine-year-old divorced editor of the *Bridle and Golfer* society magazine in Detroit, Dee Van Balkom Furey, who was born in Sumatra and educated in Paris. They were married in Toledo on March 1, 1929.

"The league of gentlemen" consisted of senior vice president John DeCamp, vice presidents Frank Montague and Milton Pollock, senior cashier Elton Graham, assistant cashier Ivan Christensen, teller and bank president's son Robert Brown and tellers James Barron, Mark Kelly, Robert McDonald, Clifford Plumb, Russell Runyon and Arthur Schlosser. They individually desired to live a little better, but together they were now too deep in speculating bank funds to escape.

So when the crash hit, the losses—which were estimated by Montague at $3,592,000—could no longer be hidden. Mott demanded the conspirators' resignations and sent them home. After contacting county prosecutor Charles Beagle, Mott withdrew the exact amount of the losses from his own private bank account in Detroit and led a convoy of three armored cars, delivering the cash to UIB to reimburse the losses. This earned Mott the praise of Governor Fred Green and of the *Flint Daily Journal*, which stated in an editorial that Mott's action "is further justification of the esteem of Flint for this outstanding citizen." The *Detroit News* simply stated, "Here Is One Big Man!"

The management changes for UIB were announced on November 5. President Grant Brown resigned, even though he was not involved in the scheme. Mott was the bank's new president. That report de-emphasized the

The 1929 ad in the *Flint Journal* announcing the merger of the Industrial Savings Bank and the Union Trust & Savings Bank into the Union Industrial Bank. *Courtesy of the Flint Public Library.*

unfolding scandal. To prevent potential panic—which could seriously affect the local economy—*Flint Journal* editor Michael Gorman urged restraint to Associated Press subscribers in reporting the news story to make sure all the facts are found and verified before giving the complete report ten days later.

On January 28, 1930, the "gentlemen" were given their sentences. DeCamp got ten years, Christensen got seven and a half years, Graham, Kelly, Pollock and Runyon got five years, Montague three and a half years, Barron got two years, Schlosser got one year and Robert Brown, McDonald and Plumb got six months. They all served time together at the state prison in Jackson, eventually putting the prison's records in order.

Union Industrial Bank moved into the new Union Industrial Building, Flint's tallest building, in 1930. While Mott may have saved UIB after the embezzlement, UIB would not survive the Great Depression. It closed along with every other bank in the United States during the 1933 Bank Holiday and never reopened. The impounded deposits of that bank and another failed bank, First National Bank of Flint, were freed by the formation of a new bank, the National Bank of Flint, in 1934. It was located in the Union Industrial Building. In 1942, National Bank of Flint was sold and absorbed into Lansing-based Michigan National Bank. In 1944, the C.S. Mott Foundation bought the Union Industrial Building, and it was renamed the Mott Foundation Building. The bank in that building evolved into the local operations of Bank of America, which closed the Mott Foundation Building office in 2013. The following year, Bank of America's Flint-area operations were sold and converted to Huntington National Bank branches. (See the next chapter.)

As for Mott's marriage to Dee, who had a nine-year-old daughter named Denise, bad weather cut short the honeymoon flight to Arizona. After spending the night in Anderson, Indiana, they continued the honeymoon trip by train. Back at Applewood, the city gal was not content with living on a gentleman's farm, which the Applewood estate was at that time. While both were adept at riding horses and a horse was purchased for Dee—named Hercules—the marriage was a struggle. Both had separate business trips they had to attend to, and they often spent nights at their Detroit apartment. A vacation first-class voyage to Europe on the SS *Paris* in June did not improve their relationship. After eight months of discord, citing irreconcilable differences, they were divorced on December 2, 1929, with Dee getting nearly $2 million in the divorce settlement as well as Hercules, who was sent to her farm near the Detroit suburb of Grosse Pointe. Mott would finally find true love in a distant cousin, Ruth Rawlings, whom he met in 1932 and married on October 13, 1934.

This chapter was inspired by the book The Day the Bubble Burst *by Gordon Thomas and Max Morgan-Witts. Thanks to Megan McAdow of the Ruth Mott Foundation.*

The History of ~~National Bank of Flint~~ ~~Michigan National Bank~~ ~~Standard Federal Bank~~ ~~LaSalle Bank~~ ~~Bank of America~~ Huntington National Bank

On Friday, September 12, 2014, the Flint-area branch offices of Bank of America closed permanently at noon. The following Monday, September 15, the branches reopened as the Huntington National Bank. Huntington was founded in 1866 in Columbus, Ohio, by Pelatiah Webster "P.W." Huntington. Huntington's Flint operations go back to the depths of the 1930s Great Depression.

The National Bank of Flint was founded on January 30, 1934, to free up the impounded deposits of two failed banks that did not reopen after the 1933 Bank Holiday: Union Industrial Bank and First National Bank of Flint. The following day, National Bank of Flint opened its doors at 9:00 a.m. in the former Union Industrial Bank Building, today the Mott Foundation Building, which housed the local banks up to Bank of America. The president of National Bank of Flint was Robert T. Longway.

The wartime economy after the 1941 Pearl Harbor attack had the National Bank of Flint concerned about the possible impact of wartime restrictions on Flint's auto industry, so it expressed interest in a buyout offer from Lansing-based Michigan National Bank.

Michigan National Bank was founded on December 31, 1940, by banking official Howard J. Stoddard, who orchestrated the merger of banks in Lansing, Grand Rapids, Port Huron, Battle Creek, Saginaw and Marshall to create the new bank. Stoddard had served as the federal

A 1940 National Bank of Flint ad from the *Flint Journal. Courtesy of the Flint Public Library.*

official for the Reconstruction Finance Corporation in Michigan to provide help to failing banks during the Great Depression. Stoddard was familiar with the National Bank of Flint, as he helped to organize it.

The directors of the National Bank of Flint voted to dissolve the bank on March 12, 1942, and sell its assets to Michigan National. A former Flint trust company official who had moved to Boston, Fred Lavery, returned to Flint to become Michigan National's senior vice president in charge of the Flint branch. Local advertising for Michigan National Bank made it clear that control of the bank and the issuing of loans would remain in the hands of Flint bank officials. The World War II boom made the Flint branch of Michigan National Bank very profitable.

At that time, Michigan had tough banking laws. Banks could only establish branch offices within a twenty-five-mile radius. As Michigan National was based in Lansing, it could only establish additional branches in the Lansing area. This forced the Flint office of Michigan National to operate only in its downtown location in the Mott Foundation Building. In 1962, Michigan National opened a drive-through office downtown at the corner of First and Beach Streets, later a Chase drive-through branch which has since closed. Michigan National got around the branch office restriction for Flint by connecting the drive-through office with the main office in the Mott Foundation Building via a pneumatic tube buried underground.

In 1966, a new three-story office addition for Michigan National's Flint branch was built adjacent to the Mott Foundation Building at the former site of the Strand Theatre. Today, it's the Commerce Center Building.

When legislation was enacted in Michigan to allow for bank holding companies in 1972, Michigan National Bank founded Michigan National Corporation as the bank holding company so that it could establish branches within the twenty-five-mile radius. The bank Michigan National Corporation established for the Flint area was named Michigan

National Bank–Mid-Michigan. It opened its first office on Miller and Linden Roads in 1973 and eventually took over the downtown location.

Losses that Michigan National suffered in the early 1980s due to the bank holding company's exposure to two major bank failures led to the shedding of half of Michigan National's 700 ATMs and the closing of 140 of its 340 branches, including half of Michigan National Bank–Mid-Michigan's 20 area branches. The holding company struggled to remain independent in the midst of setbacks and banking deregulation. One such deregulation in 1988 allowed for statewide branch banking and allowed Michigan National Corporation to consolidate all its affiliate banks into one bank called Michigan National Bank. In 1995, Michigan National Bank was sold to Australia National Bank.

In 2000, Australia National Bank sold Michigan National Corporation to the Dutch financial institution ABN AMRO. ABN AMRO already owned a Michigan-based financial institution, Standard Federal Bank. On October 9, 2001, ABN AMRO merged Standard Federal Bank (founded in Detroit in 1893) with Michigan National Bank. The combined bank adopted Michigan National's national bank charter, so the name of the merged bank became Standard Federal Bank N.A. for National Association. All banks with charters issued by the U.S. Treasury Department's Office of the Comptroller of the Currency must either have the word "National" in its name or the initials N.A. afterward.

ABN AMRO's American subsidiary was LaSalle Bank Corporation, which also owned Chicago-based LaSalle Bank N.A. On September 12, 2005, Standard Federal Bank N.A. changed its name to LaSalle Bank Midwest N.A. in what was called a "brand consolidation" instead of a merger in order to combine marketing resources.

In 2007, ABN AMRO agreed to be taken over by a consortium of three European banks. In a side deal, LaSalle Bank Corporation was sold by ABN AMRO to Bank of America, based in Charlotte, North Carolina. On October 1, 2007, Bank of America officially took over LaSalle. Over the following few months, sign companies, including Earl Daup Signs locally, replaced LaSalle Bank signs with Bank of America signs, which were shrouded with LaSalle Bank temporary canvas signs. On the weekend before Monday, May 5, the LaSalle shrouds were removed to reveal the Bank of America logo. LaSalle signs that were not replaced in time, such as at the Mott Foundation Building downtown, were covered with Bank of America canvas signs.

The immediate effect of Bank of America's October takeover of LaSalle was access to all Bank of America and LaSalle ATMs by Bank of America

and LaSalle Bank ATM cardholders as well as the ability of LaSalle ATM cardholders to access ATMs worldwide, fee free, of banks that are members of the Global ATM Alliance including Bank of America and Scotiabank in Canada.

Being a trillion-dollar megabank, Bank of America became the target of critics who believe the bank is too big and abusive. Members of the Occupy Flint movement picketed the Bank of America downtown office in the Mott Foundation Building in 2011. The downtown location closed in 2013 due to declining business.

On May 11, 2014, Huntington's holding company Huntington Bancshares Inc. bought from Bank of America its operations in the Flint, Monroe, Holland and Muskegon areas. The month before, Huntington bought Bank of America branches in the Saginaw, Alma and Port Huron areas. In 2013, Huntington had started establishing offices inside Meijer stores, including stores in the Flint area. The sale had saved the branch on Ballenger Highway, as it was slated to be closed by Bank of America but Huntington wanted that branch to stay open. The sale also included most deposits at the banks, but not the outstanding loans, which stayed with Bank of America. Earl Daup Signs returned to change the signs from Bank of America to Huntington.

This writer's checking account was not included due to its ties with an investment account with co-owned Merrill Lynch, but I was able to transfer the checking account to Huntington. In late August, new Huntington signs were erected, shrouded with temporary covers with the Bank of America name. As mentioned, the conversions took place the weekend before the former Bank of America branches in the Flint area reopened as Huntington branches on Monday, September 15, 2014.

Because credit card accounts were also not transferred, this writer was able to apply for a Huntington credit card online and began using that card on September 1. After all the Bank of America credit card transactions went through, I cashed in the bonus points, paid off the Bank of America credit card bill at a branch and closed the credit card account with the help of the Bank of America branch officers who were retained by Huntington. Afterward, the old card was shredded. The new Huntington ATM card arrived the Thursday after the changeover. The Welcome to Huntington introduction package—without new checks—arrived in the mail the following day. The Huntington checks finally arrived the following Wednesday. The next day, I had an appointment with a Huntington investment specialist to arrange transferring the investment accounts from Merrill Lynch to Huntington Investment Company.

In January 2016, Columbus, Ohio–based Huntington Bancshares bought Akron, Ohio–based FirstMerit Corp for $3.4 billion. Nearly four years beforehand, FirstMerit had bought and absorbed Citizens Republic Bancorp, parent of Citizens Bank whose downtown Flint headquarters is topped off by the landmark weather ball. After FirstMerit absorbed Citizens, the original $C B$ neon letters were replaced by $F M$ letters and FirstMerit's diamond-shaped logo. Huntington completed its acquisition of FirstMerit in August 2016. This led to Huntington fielding questions on the status of the weather ball. Huntington assured Flint residents that the weather ball would be retained and refaced with new letters. In November, Huntington began makeovers of FirstMerit branches and Bill Carr Signs replaced signs which were shrouded with temporary FirstMerit signs. Conversion of FirstMerit branches into Huntington branches took place beginning February 17, 2017, after the branches closed, with the conversions made over the Presidents' Day weekend. Two overlapping branches, a FirstMerit branch in Flint on South Saginaw Street across from the Great Lakes Technology Centre and a Huntington branch in Grand Blanc on South Saginaw across from the Grand Mall closed permanently at the close of business on February 17. The remaining Flint area FirstMerit branches reopened as Huntington branches on February 21.

The Flint Farmers' Market

The Flint Farmers' Market has been a part of the downtown Flint area for well over a century. Previously known as either the Flint Municipal Market or the Flint City Market, its earliest recorded origins date back to 1905.

In 1905, Flint had a population of just fifteen thousand. That was the year the city celebrated its golden jubilee, marking the fiftieth anniversary of Flint's incorporation into a city. The open-air market first opened at the southeast corner of Beach and Kearsley Streets. But the presence of wagon ruts over the years and congestion caused by the rise of the horseless carriage in 1912 led to the moving of the municipal market outside downtown to the west side of what is now Grand Traverse along the north bank of the Flint River. This proved to be an undesirable location, as it struggled during the World War I years and didn't even open in 1917.

After the war, it was decided to move the municipal market closer to downtown at the southeast corner of Harrison and Union Streets on the present site of the University of Michigan–Flint campus where the Thompson Library now stands. A permanent structure supported by steel trusses was built in 1920. This location for the municipal market proved to be successful, as it began to be open daily in June 1921 under market master L.C. Carey. At that time, it opened at 7:00 a.m., with trading continuing until noon. According to Carey, "To the early will go the bargain for Mr. Farmer must needs dispose of his goods and be back to his work this fine weather." This implies that a typical farmer doing business at the market

sells his produce in the morning so he could be working back on the farm in the afternoon with the long summer days.

Carey "attributes the daily market to the quantity of fresh fruit and produce now arriving, which to the best benefit of the consumer must be consumed the day it comes from the farm. Just now strawberries, asparagus, lettuce, radishes, spinach, shallots and parsley hold the center of interest, together with dairy products, but raspberries and other fruits are promised a little later on."

In 1940, one of the organizations formed under President Franklin Roosevelt's New Deal, the Works Progress Administration, built the new municipal market along the Flint River on East Boulevard Drive. Construction began on the five-acre lot on June 20. In July of that year, one of the structures at the Harrison and Union municipal market locations, the fully enclosed building known as the green market, was dismantled. Sections were moved to the new market by WPA workers. Related to that project, paving bricks removed from Industrial Avenue for a resurfacing project were moved to the new market site as well as to Bishop Airport. The old trolley tracks on Industrial were recycled to form the pilings anchoring the new market's cement floor. The steel trusses from the Union Street building were moved to the new site on railroad cars.

The planned completion was Labor Day, but delays because of rainy weather conditions and a shortage of some types of WPA work delayed completion of the project until October and November.

With construction continuing, the official opening date of the new market was set for Tuesday, October 22, with market days set for Tuesdays, Thursdays and Saturdays. The old market location on Union Street was closed for the last time the previous Saturday. The new structure with a second story at one end was also called the green market originally. The office and meat market were not yet finished, with the planned completion of the meat market in November. Finishing work still in progress upon opening included hanging doors, cleaning and upstairs bricklaying. Market hours were from 7:00 a.m. to 5:00 p.m. Construction cost for the new market in 1940 dollars was around $60,000, of which the city's share as sponsor totaled $26,486.

With the closing of the former location, WPA crews began tearing down the remaining structures and clearing the land to make way for a parking lot holding 145 vehicles.

Fast forward to the year 2002. The City of Flint was in financial straits. Since 1998, the city market has been losing an estimated $60,000 annually. Faced with a multimillion-dollar deficit, it was announced in May 2002

The Flint Farmers Market along the Flint River under construction. *From the Flint Market Revitalization Strategy, Flint Farmers Market, Flint, Michigan. Published by Project for Public Spaces Inc., November 2007.*

that the market might close. But a number of concerned citizens and organizations were invested in the market's future. In June, the nonprofit Uptown Reinvestment Corporation announced that it would lease the market from the city for at least seven years and not only keep the market open but also undertake much needed renovations.

Uptown solicited volunteers to help in sprucing up the market. The organization had hoped for 150 to help out, but as it turned out, more than 240 people volunteered from throughout Flint and Genesee County to paint, polish and plant.

In 2009, the Flint City Council approved the renewal of Uptown Reinvestment's lease on the Flint City Market. The approved lease was for twenty years, up through June 30, 2029. The rental fee was one dollar per year, with Uptown responsible for all utilities, insurance, upkeep and improvements.

But the seventy-plus-year-old Farmers' Market was in need of major improvements. The existing facility had become too small. The electrical and plumbing was maxed out and needed upgrading. The lack of an

elevator to the second floor meant that the building violated the Americans with Disabilities Act. So what to do? The market along the river was voted America's most loved in 2009. The location was perfect for motorists, as it was just off the I-475 expressway and perfect for pedestrians and bicyclists as it was located alongside the Flint River Parkway.

As the *Flint Journal* was scaling back its operations, moving its offices to smaller quarters in the Rowe Building on South Saginaw Street and consolidating production with its co-owned daily papers in Saginaw and Bay City with printing in Bay City, its production and distribution center on East First Street became available. So, on March 8, 2013, Uptown Development announced that it would be moving the Flint Farmers' Market from Boulevard Drive back to downtown in the old Flint Journal production building. It also showed drawings of how the new market would look. The announced move proved to be controversial, with several shoppers and at least two vendors announcing their opposition to the move. The big concern was with parking downtown, especially with the parking meters during business hours.

Demolition began on October 31 on the west side of the building to make room for additional parking. The new market would have more than twice the indoor space compared to the old market, with an outside pavilion along First Street. The final day of business at the location along the river was Saturday, June 14, 2014. Many shoppers were there the final day to say goodbye to the old farmers' market. The following week, Saturday, June 21, a large crowd was present at a ribbon-cutting ceremony to welcome the new market. The ground floor was ready for the throng of shoppers. Unlike the former market location, all the vendors are on the main floor.

The downtown location made the Flint Farmers' Market even more popular and busier than ever. The Flint Farmers' Market is open on Tuesdays, Thursdays and Saturdays year-round.

If Blackstone's Pub's Walls Could Talk

Blackstone's Pub has been a popular downtown Flint eatery since it first opened in 2009. The restaurant's interior not only showcases downtown Flint history but also the building's own proud history.

While the front façade of Blackstone's is two stories high, it's actually a single story with a high ceiling. The back façade, original to the building, is three stories, with signs that it was once taller. The third story—which is above the current roof—has an eternally open window exposed to the sky. The Blackstone's Pub building was originally the six-story Buckingham Building and featured the State Theatre as its main tenant.

Local theater owner Lester Matt built the State in 1924 on the site of the Orpheum Theatre, which was built in 1913 by Lewis and Frank Buckingham. Matt, who started leasing the Orpheum in 1919, also owned the Strand Theatre, two buildings up the block from the State where the Commerce Center building now stands. Postcards of downtown Flint during that era included cards that showed both the Strand and State Theatres. The State Theatre first opened at noon on February 24, 1925.

The theater's grand opening ad in the *Flint Journal* proclaimed that the State was positively a fireproof building, equipped with the most modern theater equipment. It had good lighting effects, a gold fiber screen that did not harm the eyes and perfect ventilation at all times. It served bubbling ice-cold water from a 250-foot well. The State had a seating capacity of 1,150 on both its main floor and balcony.

Because the movies had not yet talked when the State opened, the silent films were accompanied by an eight-piece orchestra, and the theater

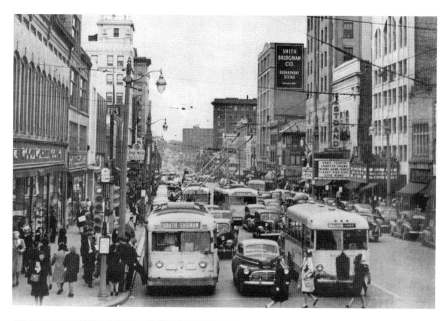

Above: Vintage Saginaw Street photo with the six-story State Theatre on the right. Note that the Strand Theatre had a more contemporary marquee than the State Theatre, which was never updated. *From the book* Transit's Stepchild: The Trolley Coach *by Mac Sebree and Paul Ward, published in 1973.*

Left: Vintage State Theatre ad in the *Flint Journal* promoting the Flint premiere of the *The Jazz Singer*, which was the first talking movie shown at the State after it was retrofitted for sound. *Courtesy of the Flint Public Library.*

was equipped with a pipe organ. The first film to play at the State was the romantic mystery *K–The Unknown* starring Virginia Valli and Percy Marmont. Along with the theater, there were two small storefronts on either side of the lobby, and the basement housed a barbershop and a store. Above the lobby, there were offices served by stairs and an elevator and a top-floor ballroom.

The theater was retrofitted to show talking movies in late 1928 and showed its first talking film on January 5, 1929, with the first Flint showing of the first talking picture, *The Jazz Singer*, starring Al Jolson.

Matt also owned two neighborhood theaters: the Roxy at 1409 Broadway on the east side and the Della at 807 Welch Boulevard on the west side. In 1940, Matt sold his theaters to the W.S. Butterfield Theatres, the dominant theater chain in the Flint area.

With the arrival of television in the 1950s, the marginal theaters began to close one by one. One of the first was the State in 1952, which at that time was showing double features of re-released B movies. The final double feature played at the State on February 24, 1952, exactly twenty-seven years after it first opened. The films were *Werewolf of London*, a 1935 film starring Henry Hull and Valerie Hobson; and *Phantom of Paris*, which was originally titled *Mystery of Marie Roget*, a 1942 film starring Maria Montez and Patric Knowles.

It looked as if Butterfield Theatres lost its lease on the State, as the opening and closing dates were exactly the same. The State's marquee was never updated, unlike the Strand, as shown in later photos of the State. When the State opened in 1925, admission was forty cents for the main floor, thirty cents for balcony seating and ten cents for children. When the theater closed in 1952, admission was forty cents for adults and fourteen for children, so the State's admission prices weren't really affected by inflation.

Demolition crews went to work tearing down most of the theater almost immediately upon closing, and the building was converted entirely into retail space. The Winkleman's women's clothing store took over the building in 1953, but the left storefront was kept for Gumm's Jewelers, which remained after the partial demolition. Winkleman's had left downtown Flint for the new suburban malls by 1970. The Blackstone's men's clothing store took over in 1970. Gumm's Jewelers closed in 1971. By 1976, Harry Hopkins Jewelry had taken over the Gumm's space, but it was only around for a couple of years. In 1980, a U.S. Army recruiting office took over the small storefront, but it had moved out by 1985. Olde Discount Stockbrokers had taken over that space by 1987. After Blackstone's closed the downtown store

around 1987, it became mainly storage space. Olde's left the building for Linden Road around 1991.

When Uptown Reinvestment began its project to rehabilitate and demolish vacant buildings in the block south of the Mott Foundation Building in 2007, the early architectural drawing for what was first called the Mott Block project showed the Blackstone's building with a façade similar to the original façade for the Strand Theatre before that theater was enlarged and received a new façade in 1919. Uptown Developments' project developer, Ridgway White, foresaw the flexible space being used for entertainment-oriented retail or a restaurant that could offer entertainment.

The renovation of the old Blackstone's into Blackstone's Pub & Grill a couple of years later made the plan a reality, albeit with a more contemporary façade that utilized the old Blackstone's sign. The adjacent Wade Trim building, which houses the Wade Trim engineering firm and WNEM-TV, has a studio with plate-glass windows along Saginaw Street so passersby can view productions. While the 2007 plans included a drawing of the former Copa nightclub—the former Vogue women's clothing store—that was torn down in 2008 to create green space and give Wade Trim tenants on the south end of the building more exposure.

If you look closely at the walls of Blackstone's Pub's interior, you can still see bits and pieces of the old State Theatre.

The Flint Cultural Center

As the city of Flint was approaching its centennial year of 1955, there was not much culture in the blue-collar city. In the 1950s, Flint did have the Flint Community Players, which staged shows in local school auditoriums. The Flint Institute of Arts was established in 1928, and in 1955, it was located downtown at 215 West First Street west of Beach Street in a building that no longer stands. There was not a proper concert hall, only theaters built for vaudeville shows or movies.

But one very influential man, the *Flint Journal*'s editor, Michael A. Gorman, had big ideas to provide culture to Flint. Charles Stewart Mott, a General Motors director who headed the Charles Stewart Mott Foundation, had plans for improved higher education facilities for Flint when he learned that the University of Michigan wanted to add additional campuses in 1946, and Mott wanted a U of M campus in Flint. Those two men provided the springboard for the Flint College and Cultural Development, which received a $3 million boost in 1954 when General Motors announced it would contribute $3 million toward it.

The Flint College and Cultural Development had a $12 million goal for the centennial year of 1955. There were grandiose plans for the construction of a three-thousand-seat auditorium, a transportation and historical museum, an art center, a theater, a carillon and a planetarium. Most of the land was provided by Mott from his Applewood estate and from the Flint Board of Education, which owned the old Oak Grove Campus, at that time home of Flint Junior College (now Mott Community College). In 1955,

Flint Junior College moved to a new thirty-two-acre campus across Gilkey Creek on former Applewood land that housed Ballenger Field House, the Curtice Building and the Mott Science Building, the earliest structures to make up the current Mott Community College campus. Two years later, the Mott Memorial Building was completed, housing the Flint College of the University of Michigan, the forerunner of the University of Michigan–Flint. After the U of M–Flint downtown campus was completed, Mott Community College took over the Mott Memorial Building.

A campaign began in 1954 for the general public to contribute increments of $25,000. Eventually, more than four hundred individuals and nearly one hundred companies and associations became sponsors. The Flint Board of Education was chosen to administer the Flint Cultural Center facilities.

The first facilities to open their doors in 1958 were the Robert T. Longway Planetarium; the Enos A. & Sarah DeWaters Art Center, the new home of the Flint Institute of Arts; the Flint Public Library; and the F.A. Bower Theatre, which seated 352 and boasted noted actress Ethel Waters starring

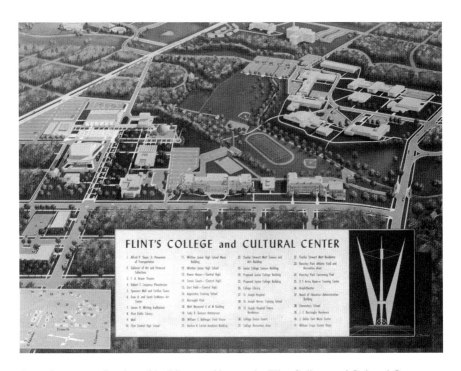

An early concept drawing of buildings making up the Flint College and Cultural Center. *From the booklet* Flint's Community College and Cultural Center *by the Committee of Sponsors for the Flint College and Cultural Development Inc. and the Flint Board of Education, published circa 1958.*

in the first show staged there. All these facilities were located on the south side of Kearsley Street.

On the north side of Kearsley Street, the Durant Plaza was built in 1958 in memory of General Motors founder Billy Durant, and Mabel Marcia Webb Dort, widow of J. Dallas Dort, donated the stately Dort family home as a music school and the start of what became the Flint Institute of Music. In the 1960s, that side of Kearsley Street received new construction to enhance the Cultural Center. In 1966, the Alfred P. Sloan Museum was built. The following year, in October 1967, the 2,043-seat James H. Whiting Auditorium was completed. Between the Sloan Museum and the Whiting and north of Durant Plaza, the Flint Board of Education built the Sarvis Food Center as a conference center with banquet facilities in 1967.

Between Longway Planetarium and the DeWaters Art Center, there was a reflecting pool (later enhanced by a fountain) and a series of granite monoliths with the names of donors who contributed to the college and cultural development, with extra space to add additional donors in the future.

In 1970, construction began to expand the Dort Music Center, but during construction, the original Dort house was destroyed by fire. Many of the surviving pages of sheet music had to be laid out individually to dry before mold and mildew could set in. The expanded Dort Music Center, housing the Flint Institute of Music, was completed in 1971.

As the years went by, economic challenges regarding maintenance of the facilities became apparent, as the Flint Board of Education faced budget challenges. After meetings between the board of education and the center's committee of sponsors, the Flint Cultural Center Corporation was formed to manage the Cultural Center in 1992.

In 1999, Whiting Auditorium was renovated and gave itself a simplified name, the Whiting. In 2000, an addition was built connecting Longway Planetarium and Bower Theatre, expanding the planetarium's lobby and adding additional classroom space. The Flint Youth Theatre, which used Bower Theatre, added additional rehearsal space plus an additional performance venue, the Elgood Theatre.

In 2005, the Flint Institute of Music completed renovation and expansion of the Dort Music Center.

In 2007, the Flint Institute of Arts greatly expanded its space with additional galleries, a meeting space, a café and a gift shop. In the process, it lost the deteriorating reflecting pool that was damaged during construction, the fountain and the crumbling granite monoliths. The facility was now officially called the Flint Institute of Arts instead of the DeWaters Art

Center. But a plaque next to the front entrance does pay tribute to the former name. As for the names of those who donated funds that were on the monoliths, there is now a series of signs with those names on the side of the Whiting. Construction began in 2016 at the FIA of a contemporary craft wing to be completed in late 2017 offering glass blowing and metal casting classes and demonstrations.

In 2015, the Longway Planetarium was extensively renovated and reconfigured with state-of-the-art equipment to provide a wider range of programs, including lectures, film presentations and live performances, as well as the traditional planetarium shows.

Besides changes in the physical facilities, there were also changes in the organizational structure. In 2003, the Flint Youth Theatre's management was moved from the Flint Board of Education to the Flint Cultural Center Corporation (FCCC). In 2004, the management of the Sloan Museum and Longway Planetarium was consolidated into Sloan*Longway, which also manages the Buick Gallery and Research Center, located in the former Arctic Dairy at the corner of Walnut Street and Longway Boulevard.

In 2004, the board of education transferred ownership of Cultural Center buildings, except for the Flint Public Library and Sarvis Center, to the FCCC. But the board of education's continued financial problems led it to sell the Sarvis Center to the FCCC in 2013 for $150,000. The FCCC considered several ideas on what to do with that facility, but eventually, it was decided to tear it down in 2015 to provide green space and allow for a grander entrance to the Cultural Center from Longway Boulevard.

What became of the carillon that was planned in the beginning? It was never built. There's a story that the steel for the carillon was stored inside the former J. Dallas Dort home, but it was lost in the 1970 fire that destroyed the Dort residence.

War Hero Owen Hammerberg, Hammerberg Road and "The Rock"

I t all began with a World War II hero who lost his life saving others underwater at Pearl Harbor. His heroism led to a major road bearing his name and a landmark concrete canvas at the end of that road.

Navy Boatswain's Mate Second Class diver Owen Hammerberg moved with his family to Flint while in high school. He dropped out and moved west before joining the navy in 1941. He was trained to be a deep-sea diver and assigned to the Commander Service Force, U.S. South Pacific Fleet, Salvage Unit in Pearl Harbor, Hawaii. Hammerberg was part of a diving team assigned to raise sunken ship tanks to clear the sea channel. But in February 1945, members of another diving team became trapped underwater, entangled in the steel and cables of a downed ship.

Hammerberg volunteered for the rescue mission. He spent five hours rescuing one diver, but in rescuing a second diver, he was crushed by a heavy plate he moved to save that diver.

In giving his life to save the lives of two others, Hammerberg was posthumously awarded the Metal of Honor, the last noncombat medal awarded in Michigan during World War II. He also received the American Defense Service Metal Fleet Clasp, Asiatic-Pacific Campaign Medal, the American Campaign Medal and the World War II Victor Medal. These medals and his uniform were put on display at the Michigan Military and Space Museum in Frankenmuth.

Flint's postwar growth led to the building of new roads to serve new factories. These included the new General Motors factory buildings on

Messages are painted on "the Rock." *Top*: a birthday salute; *middle*: a birthday greeting to Sheri Lynn; *bottom*: A memorial. *Gary Flinn*.

Van Slyke and Bristol Roads. In Flint, Twelfth Street became Torrey Road and passed by the new factories. But Torrey Road would be interrupted in the 1950s by construction of the Fenton-Clio Expressway, which became part of Interstate 75. When I-75 was built, the portion of Torrey Road that connected to Twelfth Street was curved to connect to Rablee Road, which connected to Ballenger Highway. Eventually, that portion of Torrey Road was renamed Twelfth Street, and Rablee Road was renamed Ballenger Highway to simplify the map.

In 1955, a new road connecting Miller Road with Torrey Road (now Twelfth Street) was named Hammerberg Road in memory of Owen Hammerberg. Because the intersection of Torrey and Hammerberg was below grade, a concrete pump house was built at the end of Hammerberg to prevent flooding after heavy rains.

In 1959, Flint Southwestern High School (now Flint Southwestern Academy) opened its doors nearby. In 1970, the M-78 (now I-69) freeway extension from Swartz Creek to downtown was completed with an exit at Hammerberg Road. This gave Hammerberg Road, Southwestern High School and the concrete pump house at the end of Hammerberg Road increased exposure.

Around 1970, the bare concrete structure was spray painted with its first message. The word BOWLIPS in all capital letters was written in blue. Bowlips was believed to be the nickname of a German exchange student who was attending Southwestern around that time. Later on, in a display of school spirit, "SWP Oh Yeah" was painted on the still bare concrete. SWP stood for Southwestern Pep. It did not take very long for the structure—dubbed "the Rock"—to become a community canvas and billboard. Over the years, many messages and artistic works were painted on the Rock. Often, the Rock was painted over twice in one day. The artists usually used low-priced paints and did not consider the types of paint used. One crew would use oil-based paint, and others would use latex-based paint, which does not stick to oil-based paint.

All those layers of paint over the years were bound to eventually fail. On June 11, 2014, several inches and numerous layers of paint peeled away from the concrete. Surprisingly, souvenir hunters collected all those layers of paint as keepsakes. The much thinner rock was not bare for long, as new messages and works of art continue to be painted on this southwest Flint landmark.

The First Flint Water Scandal

L et's go back to the mid-1950s. The Flint area was still growing, and the auto plants were humming. Flint was getting its water from the Flint River. The river water was treated at the Flint Water Plant on North Dort Highway at Stewart Avenue.

There was concern at that time that water from the river might not be sufficient in the future to meet the needs of the Flint metropolitan area. On December 13, 1955, the Boston-based firm Metcalf & Eddy Engineers released a brief titled *Report to City Manager, City of Flint, Michigan Upon Adequacy of Existing Water Supply.* In a nutshell, the report recommended that the city find a better source of water to meet future needs. Another report issued in 1963 by the U.S. Geological Survey mentioned that the city was planning a pipeline from Lake Huron to Flint to provide a more reliable source for water.

A confidential land agent for the city, Claude O. Darby Sr., had recommended the purchase of three acres of land along Lake Huron in Sanilac County's Worth Township for $75,000 on January 9, 1962. The land was intended for use as a pumping station for the proposed water pipeline. A scandal broke when it was revealed that three months earlier, Darby—through his private real estate company—had purchased the same property from businessman Samuel Catsman, who owned local construction supplier Catsman-Atlas Building Products and Catsman Realty, for $42,000 on October 2, 1961, through a Port Huron real estate agent. This transaction occurred before Darby became the city's land agent on October 25. The city later accepted $33,000 from Darby

Vintage photo of the Flint Water Plant. *Gary Flinn.*

plus his agent's fee of $1,650 after the irregularity was revealed the previous year. Darby also surrendered his real estate broker's license and resigned as president of the Darby & Son real estate firm.

Darby's trial on charges of obtaining money under false pretenses was moved by Genesee County Circuit Court judge Stewart Newblatt on November 26, 1963, from Flint to Niles, with the trial date set for December 17. On December 6, a one-man grand jury consisting of circuit court judge Donn D. Parker launched an investigation into the land deal. On that day, Parker granted Darby immunity from prosecution in exchange for testimony against Catsman. That led to the dismissal of charges against Darby by Judge Newblatt on December 13.

On December 31, 1963, Catsman was indicted on charges of obtaining $33,000 under false pretenses from the City of Flint. The chronology of events, revealed that day, showed that on January 5, 1962, Darby notified then–city manager Robert A. Carter, who was also charged, in a letter that Darby received an option on the real estate along Lake Huron—of which Catsman allegedly had knowledge. On October 2, Darby, at the request of Catsman, purchased the property in the name of Phillip T. Smith "for the ownership, benefit and gain" of Catsman.

With the trial for Catsman and former city manager Carter set for December, on April 22, 1964, the Flint City Commission voted to scrap

plans for the water line from Port Huron to Flint and instead join the Detroit Water System. The vote was 7 to 2.

Catsman and Carter's trial would be heard by visiting Port Huron circuit judge Edward T. Kane, who rejected a change in venue motion to move the trial to Port Huron. While Catsman waived his right to trial by jury, a jury was chosen for Carter. The trial began on December 3, and the state rested its case on December 10. On December 11, Judge Kane dismissed the case, clearing Catsman and Carter of charges, declaring that the entire conspiracy matter was the result of "greed" on the part of Darby and destroyed his career as a real estate agent.

On December 15, 1967, Detroit water began flowing into Flint. Detroit had built a pipeline from Troy to Imlay City and another pipeline from Imlay City to Flint. Detroit had already made plans for a pipeline from Lake Huron to Imlay City. In 1974, Detroit's Lake Huron Water Treatment plant became operational. In 1976, the Michigan Department of Public Health determined that Flint's water supply was unreliable, as there was no backup source for water, so it pressed the city and the Detroit Water and Sewerage Department to develop a backup source. Detroit proposed a new line along I-75 to provide one in 1981, but it was never built, due to funding and line size disputes. In 1990, Flint made improvements to its water treatment plant to provide a backup source.

As the years passed by, rate increases by Detroit had made Flint water unusually expensive. For decades, officials have complained of high costs for the water and a price formula that penalizes this area because of its distance from Detroit and its elevation. While Genesee County was paying $8 million for Detroit water in 2001, it was paying $33 million for the same amount of water fourteen years later. Another factor was a power outage in 2003 that affected the Detroit water system and led to water supply problems farther up the pipeline. That led to plans for a rival water pipeline from Lake Huron to commence in 2007 and the formation of the Karegnondi Water Authority (KWA), consisting of the city of Flint, Genesee County, the city of Lapeer, Lapeer County and Sanilac County, in 2010.

The KWA proposed building a pipeline from Lake Huron to Flint, with participating local governments along the route sharing the cost. Unlike the Detroit pipeline, which provides treated water, the KWA pipeline would provide untreated water that would then be treated by the local water departments. The pipeline route closely follows the planned route of the scrapped 1960s pipeline. Unlike the scrapped pipeline, the new pipeline would follow existing public right of ways and easements, keeping the

purchase of required real estate to an absolute minimum. The water intake location (in Sanilac County's Worth Township, the same area where the 1960s scandal–plagued land was located) was already acquired in 2002 by the Genesee County Board of Commissioners in a public auction of land sold by Detroit Edison.

To aid in the construction of the pipeline—which began in 2013—American Spiral Weld built a pipeline factory to provide pipes for the new water line in 2014 on a portion of the old Buick City factory complex site. While the pipeline itself was completed in 2016, the new Genesee County Water & Waste Services water treatment plant at the corner of Marathon and Stanley Roads in Lapeer County's Oregon Township was still under construction in 2016.

Upon completion, Genesee County customers will receive water from the KWA pipeline as soon as late 2017. Flint's customers would utilize the existing water treatment plant upon connection, but in early 2017, it was determined that the water plant would not be ready to treat KWA water until 2019 so there was speculation that Flint could buy water from the new Genesee County water treatment plant in the meantime.

The City of Flint's financial problems—which led Michigan governor Rick Snyder to appoint emergency financial managers to run the city—led to complications after the Flint City Council voted in 2013 to switch Flint's water source from Detroit to the KWA pipeline upon its completion. But the Detroit Water and Sewerage Department terminated its contract with the City of Flint before the KWA pipeline became operational, which led to the second Flint water scandal, the subject of chapter 35 in this book.

Sherwood Forest

Recreation Area, Rock Concert Venue, Dinner Theater

In the 1950s, Don Sherwood of Richfield Township decided to establish a private park and recreation area for picnics, swimming and hay rides. Sherwood's property was an L-shaped parcel fronting State Road where he lived and Richfield Road, which served as the park's address. The park had a five-acre lake and green rolling hills. He also built a seventy-five-foot- by eighty-foot hall inside the park that could host dances, weddings, political rallies and other events. In 1959, an outdoor stage was constructed. As the 1960s progressed, he added touches to enhance the Sherwood Forest theme, such as lamp posts painted in a candy-striped pattern and topped off by a statue of Robin Hood aiming his bow and arrow.

Beginning in 1964, the park added its greatest claim to fame—or infamy, depending on your point of view—by beginning to host music concerts. Among the earliest notable performers there were Smokey Robinson and the Miracles, the Four Tops, Little Stevie Wonder, the Four Gents and the Delfonics. Among the local performers in the early years were the Jazz Masters and the Derelicts, whose members would later become members of the most famous rock group to come out of Flint: Grand Funk Railroad. The dates they performed were unknown since they were not posted prior to 1968, when the bands Good Day Sunshine, the Moods, the Sunday Funnies and Wax Radish performed at Sherwood.

In 1969, an addition to the hall was built. That same year, radio station WTAC, which had a top 40 music format, began an outdoor event titled Wild Wednesday on June 18, a music festival featuring several famous and

local performers hosted by WTAC's Peter C. Cavanaugh. The first Wild Wednesday was held just two weeks before the Woodstock festival in Upstate New York, so Sherwood Forest became known as the little Woodstock. The performers at the first Wild Wednesday were the Bob Seger System, the Rationals and six local groups. Other acts that performed that year were the MC5, Dick Wagner & The Frost, Mitch Ryder's later group Detroit, the Cuff Links, Floating Circus, Hot Ice, the Bhang, Third Power, Wilson Mower Pursuit, SRC and Catfish. The second Wild Wednesday, on June 24, 1970, was called the Michigan Monster and featured the MC5, The Bob Seger System, the Amboy Dukes featuring Ted Nugent, Dick Wagner & The Frost, SRC, Teegarden & Van Winkle, Brownsville Station featuring Cub Koda, Savage Grace, the Rumor, the Sunday Funnies, Mister Flood's Party, the Tea, the Third Power, the Free and Smack Dab. Significant among the other 1970 gigs was a Super Sunday on October 10 with Augustrane, Bromfield Correy, Brownsville Station, the Maxx, Mike Quatro's Jam Band, Smack Dab, Sonny Hugg and Walpurgis.

In 1971, that year's Wild Wednesday on June 23—dubbed the Mighty Michigan Monster—attracted ten thousand people with acts such as the Amboy Dukes, Brownsville Station and Bob Seger, among others. A second Wild Wednesday was held that year on July 14 with Edgar Winter's White Trash, Guardian Angel, Ice Nine, Mr. Flood's Party, ? & The Mysterians, Savage Grace and Third Power. A third Wild Wednesday was held September 1 featuring Chuck Berry with the Woolies, Mike Quatro's Jam Band, the Rumor, Silver Hawk, Springwell and the Sunday Funnies. September 26 marked Super Sunday with, among others, Bob Seger, Brownsville Station, Catfish, Commander Cody & The Lost Planet Airmen, Plain Brown Wrapper, Smack Dab and Teegarden & Van Winkle.

For 1972, there were three Wild Wednesdays—June 21, August 2 and August 23—plus a Super Sunday on September 24. Among the performers at those concerts were Bob Seger, Dennis Coffey, Frijid Pink, the Frut, Julia, King Biscuit Boy, Mike Quatro's Jam Band, the Rumor, Teegarden & Van Winkle, Wylie, the Dogs, Guardian Angel, the Ides of March, Limousine, the Rasberries, Salamander, Sonaura, the Sunday Funnies, the Amboy Dukes, the Woolies, Catfish, the Counts, Detroit featuring Mitch Ryder, Flash, Jo Jo Gunne, Mutzie, Plain Brown Wrapper, Salem Witchcraft, Stoned Lightning, Reggie Roberts & Hot Ice, Ricebird, Smack Dab and SRC.

There were three Wild Wednesdays for 1973, and they included performances by Black Watch, the Climax Blues Band, Frijid Pink, Justice Miles, Mitch Ryder, the Rumor, Springwell, Sugarloaf, Skyhook, the Whiz

Kids, Barnstorm with Joe Walsh, Blue Oyster Cult, Detroit with Rusty Day, Father, the Frut, Lightnin', Smack Dab, Uprise, Bob Seger, Catfish, Nash, Scott, the Siegel-Schwall Band, Skin Deep and Ted Nugent.

The rock concerts and other events led to complaints by the park's neighbors, most notably orchard owner George Masters, whose orchard was adjacent to the park. In 1970, he complained to the Richfield Township board that he had to hire a guard to protect his property whenever parties were held at Sherwood Forest. When he returned from a vacation that year he found that $8,000 in damage was done to his property. Among other complaints he made were drunks found at his door, his dog poisoned, apple trees destroyed, stones through his windows and liquor and beer bottles littering his yard.

Among the patrons attending the large concerts were drug pushers. In 1973, the Genesee County Sheriff raided a Wild Wednesday concert. In 1974, Don Sherwood pulled the plug on the Wild Wednesday concerts due to mounting pressure from Richfield Township, the police and neighbors. The final Wild Wednesday that year on June 26 featured performances by Montrose featuring Sammy Hagar, Bob Seger, Spooky Tooth, Ceyz, Possum Creek, Rock & The Sharks, Salem Witchcraft, Shamrock and Sweetmama Shake Up.

There were occasional concerts up to 1980, when WWCK 105.5 FM held an outdoor show where it gave away a house trailer.

In 1980, Don Sherwood sold his Richfield Township property, including Sherwood Forest. The new owner of Sherwood Forest was caterer Barbara

A 1981 Sherwood Forest ad in the *Flint Journal*, when it was a dinner theater. *Courtesy of the Flint Public Library.*

Gleason. After making about $150,000 worth of renovations, she began promoting the new Sherwood Forest and dinner theater performances in 1981. Among the shows staged that year were *I Do, I Do, Guys and Dolls* and *The Odd Couple*.

The new owner also made the park available for catered banquets, weddings, large picnics, exhibits and outdoor recreation. The Robin Hood theme was enhanced with a medieval look: old wood, gray stones, polished floors, banners, flags, shields and swords. The banquet rooms had names such as Friar Tuck's Den, Robin Hood's Lair and King Arthur's Court. The largest banquet room could seat five hundred. For the winter season, cross-country skiing, skating and sledding were offered.

But alas, the enterprise was not successful, and Sherwood Forest had closed by 1984. In 1989, the lodge was destroyed by fire. Over time, Mother Nature had taken over the grounds. Looking overhead on Google Maps using the satellite view, you can still see the concrete where the structures once stood. But one memento of Sherwood Forest's glory days is still standing for all to see: the Robin Hood statue, albeit minus the bottom half of his bow, located at the parking lot behind Richfield Township Hall on State Road.

You can read more about Peter C. Cavanaugh in his book Local DJ. *His official website is WildWednesday.com.*

For-Mar Nature Preserve

Nature Thrives in the City

T he For-Mar Nature Preserve and Arboretum is on the site of the For-
Mar Farms.

Forbes K. Merkley was a native of Williamsburg, Ontario, who moved to Flint and entered the dairy business by joining Freeman Dairy Company as a bacteriologist. He co-founded the Saginaw Dairy Company but sold his interest in that dairy and returned to Flint to establish the Genesee Dairy Company.

In 1935, Forbes and his wife, Martha, purchased what was then called Daly Acres, at the corner of Davison and Genesee Roads in what was then Burton Township, now the city of Burton, in 1935. It was a rundown 125-acre farm with no electricity, plumbing or running water. The Merkleys renovated the farm building and cleared the land. By the 1940s, the For-Mar Farms had developed a reputation for breeding prize dairy cows. Over the years, the Merkleys bought adjoining land, so the farm grew to 380 acres and hosted 4-H club shows.

In developing the farm, the Merkleys maintained as much of the natural habitat as possible. There were undisturbed ponds and centuries-old trees still standing. They never allowed hunting on their property. They always treated their land as a wildlife preserve and at one time fed hundreds of pheasants during the winter.

Before Forbes Merkley died in 1966, he and Martha donated fifty-seven acres of For-Mar Farms property for a proposed retirement center that was never built. Genesee Dairy was in operation until 1971, when it was sold to McDonald Dairy.

Aerial photo of the For-Mar Farms before it became a nature preserve. *From the Survey Report and Outdoor Education Plan, For-Mar Nature Preserve and Arboretum by the National Audubon Society, Nature Center Planning Division. Published in 1968.*

In March 1968, Martha Merkley donated portions of the farm to the Genesee County Parks and Recreation Commission valued at $650,000. The Charles Stewart Mott Foundation's gift of $350,000 allowed the parks and recreation commission to acquire the rest of the farm acreage to create the nature preserve.

Existing farm buildings were renovated for use by the nature preserve, and the parks commission purchased an additional twelve and a half acres along Genesee Road, making use of an existing building there that was renovated.

Upon its opening on October 31, 1970, Dr. David Molyneaux of First Presbyterian Church of Flint spoke at the dedication ceremony:

Mrs. Merkley and her late husband had a mystical sense about their farm, feeling that they were stewards of what they had. They looked forward, to the future, dreaming of the day when the land would be part of some wonderful public use. Here are being sown the seeds of immortality. A certain immortality is conferred on the citizens of Genesee County, all of whom have a part in and have contributed to this preserve. Generation after generation will come to touch the greenery of God's earth and learn a little more about nature.

The For-Mar Nature Preserve and Arboretum has 383 acres of Michigan native plant and animal life, including a collection of rare and varied trees. It also contains seven miles of hiking trails developed in 1974 with over sixty guideposts. The trail system consists of short footpaths, mowed lanes and gravel roads. Martha Merkley founded the Friends of For-Mar as part of the Merkley Trust to raise funds to support For-Mar year-round. The grounds are open Wednesdays through Sundays, including holidays. Jogging and biking are permitted on the gravel service drive only.

For-Mar also includes educational buildings such as the Corydon Foote Bird Museum with its 150-plus-year-old collection of more than six hundred mounted birds that Foote, a Civil War veteran, collected along with preserved eggs during most of his life. It is open Sundays along with the Forbes and Martha Merkley Visitors Center.

The old farm buildings utilized by the nature preserve include the horse barn, which became For-Mar's maintenance building. The Quonset hut and the garage off Davison Road are used for storage. The barns and houses were torn down. The Merkleys built the vehicle bridge that is still in use. The suspension bridge and the landmark windmill were constructed after For-Mar's opening. The Potter Road garage was brought in after For-Mar opened.

In 1979, the preserve was threatened by a proposed regional shopping mall across Davison Road called Regency Square Mall. The mall was promoted by Burton mayor Richard Wurtz to be developed by Jacobs, Visconti and Jacobs of Cleveland along with the Taubman Company of Troy, Michigan, and Ramco-Gershenson of Farmington Hills, Michigan.

Opposition to the mall sprang up immediately out of concern that commercial sprawl would develop like it did after Genesee Valley Center opened in 1970. Besides, that mall would compete with the nearby Eastland Mall (now Courtland Center) in Burton. It led to legal action by opponents, and even though Burton planners okayed the mall plan and Wurtz survived a recall election, the Michigan Court of Appeals ruled on August 1981 that voters should decide on whether the land should be rezoned for a mall.

But the following month, the developers canceled the project and withdrew appeals. The poor economy at the time was blamed for the project's abandonment, with 15 percent unemployment, 20 percent interest rates and a slowdown in the auto industry.

A grant issued in 1992 by the Michigan Department of Natural Resources allowed for construction of For-Mar's Nature Center in 1995.

The latest addition to For-Mar is a treehouse, first proposed in 2014 and built in 2016. The 330-square-foot treehouse can hold thirty children plus instructors and is handicapped accessible.

Martha Merkley died on November 15, 1986, at age eighty-six. She and Forbes left no children. They are buried at Davison Cemetery on Potter Road in Davison Township.

Genesee Towers

Flint's White Elephant

The year is 1965. Flint's population had reached its peak of almost 200,000 people before the suburbs cut into the city population. Flint's big regional shopping malls had not yet been built, so downtown was still Flint's commercial center. With this in mind, 1965 was also the year one of Flint's main banks made a big announcement.

On November 20, 1965, a new eighteen-story office building with an estimated cost of about $6.5 million was announced. To be built on the southwest corner of East First and Harrison Streets, the major tenant was to be Genesee Merchants Bank and Trust Company. It would occupy the first level and one of two basement levels. The announcement was made at a noon press conference at the Flint Golf Club.

Construction required the removal of several structures: a four-story building housing Smith-Bridgman's First Street Store, Bill Lamb's Record Shop, the Mar-K dress shop, a Household Finance Company Office, Herrlich's H&S Store and the old Garden Theatre, which was built in 1939 and replaced the Bijou Theatre (renamed the Garden in 1915). The newer Garden Theatre closed in 1957 due to competition from television.

Demolition commenced on February 1, 1966, and it took about two and a half months to clear the site and prepare it for the formal groundbreaking, which took place on April 12. The building was constructed by National Building Corporation of Nashville, Tennessee, and was originally jointly owned and operated by National Building and Overseas Investors Inc. of New York City. Piper Realty Company of Flint handled the leasing arrangements.

Genesee Bank's Genesee Towers grand opening ad from 1968 in the *Flint Journal. Courtesy of the Flint Public Library.*

The design of the building incorporated a parking ramp for the second to ninth floors with a ten-story office tower above it. The building was constructed using reinforced concrete for the framework with the concrete provided by Palmer Concrete Products.

On December 2, 1968, Genesee Bank held the grand opening of its new main office at Genesee Towers. Its former main office at 352 South Saginaw Street at Kearsley Street would continue to operate as a branch office. The new office boasted free parking inside the parking ramp while banking along with up-to-the-minute facilities with a spacious, well-lighted lobby and tastefully appointed offices designed to create a relaxed atmosphere conducive to unhurried, thoughtful transactions.

In 1979, Genesee Towers welcomed a high-profile tenant when radio station WDZZ began broadcasting with studios, offices and transmitter inside Genesee Towers. Another high-profile tenant was the University Club on the top floor with magnificent views of the city.

In 1984, the holding company of Genesee Bank was purchased by NBD Bancorp, and Genesee Bank became NBD Genesee Bank. When Michigan banking laws were loosened in 1988 and allowed banks to operate branches statewide, NBD Genesee Bank's parent NBD Bancorp changed the name of its flagship bank from National Bank of Detroit to NBD Bank, N.A., and the Genesee name disappeared. The huge Genesee Bank three-sided neon sign atop Genesee Towers was dismantled and hauled away by helicopter in 1990.

On March 1997, NBD announced that it would be leaving Genesee Towers, with plans to vacate the building by mid-1998. NBD's lease on Genesee Towers expired in July 1998. The bank had leased 100,000 square feet of Genesee Towers' 172,000 square feet of office space. NBD moved its downtown office and its four hundred employees to an addition to the Plaza One office building at the corner of East Court and Harrison Streets and a newly constructed office housing the bank's back room functions in Grand Blanc Township.

By that time, Genesee Towers was being managed by Banc One Management & Consulting, which had no ownership stake but managed it on behalf of an investment trust administered by Bank of America National Trust & Savings Association of San Francisco. The trust had owned Genesee Towers since September 1996, when it foreclosed on the mortgage issued to a Texas-based real estate investment firm. The trust had to resell the property by September 1998 or face a tax penalty.

Genesee Towers has had several owners in the meantime. Ann Arbor businessmen Ned and Fred Shure bought it in 1979, joined in the venture by McKinley Properties of Ann Arbor. Stephen D. Barker, a Fenton real estate developer and Chicago-area partner Daniel J. Murphy bought it in 1985. They sold it in 1991 to Genesee Towers Inc., a Georgia corporation. Continental Mortgage and Equity Trust of Texas had controlled the building from 1993 until the Bank of America trust foreclosed on it in 1996.

But even with the multiple owners, another problem was Genesee Towers's shoddy construction. The first sign came in 1981, when a car hit a parking bumper inside the garage, causing a concrete section to fall three stories off the side of the building.

On October 1997, V. Kumar Vermulapalli was the $500,000 high bidder for Genesee Towers. But Vermulapalli's history of real estate management was questionable back then. He bought the old Genesee Bank building at 352 South Saginaw Street in May 1993 and closed it in late 1996. According to city councilman Jack Minore, "Tenants simply just left rather than put up with poor conditions." After the sale, the city valued the building at $7 million.

NBD (now Chase) closed the Genesee Towers office on May 8, 1998, and opened its new Plaza One office on May 11.

The future of Genesee Towers was uncertain. By 1999, WDZZ and its co-owned station WFDF had vacated Genesee Towers for new studios and offices in Mundy Township. The WDZZ transmitter later moved in 2007 to an existing tower located at the Flint/Genesee Job Corps Center campus on North Saginaw Street near Hamilton Avenue.

In 2001, the city cited Genesee Towers for numerous code violations, including broken fire alarms, faulty wiring and missing air filters. It was damaged by a flood in 2001.

By 2002, the University Club was gone. Councilman Minore's fears had proven correct, as Vermulapalli's supposed "improvements" to the building caused the building's conditions to deteriorate further—to the point that barricades were constructed around Genesee Towers to protect passersby

in 2002, as the building was considered to be unfit for occupancy and debris was falling from the façade. Despite the deteriorating condition of the building and the lack of tenants, the city neglected to downgrade the property's listed value.

Vermulapalli started a long and expensive legal battle with the city in 2003, accusing the city of attempting to seize the building. The parties agreed to binding arbitration in 2006. City officials tried to condemn the building that year, but in 2007, mayor Don Williamson stated that Flint had no intention of buying Genesee Towers—neither did the Land Bank. Vermulapalli was asking $3.5 million at that time. Also, in 2007, arbitrator and former judge Valdemar Washington ordered that the city take ownership and award Vemulapalli $6 million. The city appealed, but the Michigan Supreme Court declined to hear the case in 2010. So Flint taxpayers were forced to pay what became an $8 million judgment in their December 2010 property tax bills. Every Flint property owner was charged an extra 6.751 mills, averaging about $133 for a typical Flint home.

The last time Genesee Towers was utilized was during the downtown Flint ArtWalk on July 8, 2011, when the Fischer Bodies performed there.

The implosion of Genesee Towers. *Gary Flinn.*

With the condition of Genesee Towers, the feelings of a lot of people, including this writer, was that it must be torn down. One of the last acts of emergency financial manager Michael Brown was to sell Genesee Towers without public notice to Uptown Reinvestment Corporation for one dollar, which inspired a protest banner hung from Genesee Towers.

It was decided in 2013 to implode the building. Explosive charges were placed at several locations drilled inside the reinforced concrete framework. Surrounding buildings were protected. Just across Brush Alley, the Mott Foundation Building was protected by several shipping containers stacked on top of one another, a protective fabric and boarded up windows. The Capitol Theatre was covered in clear plastic film, and the old Flint Journal building was also protected with stacked shipping containers and protective fabric.

Genesee Towers was imploded the morning of December 22, 2013. Video cameras were set up to record the implosion from the Capitol Theatre and the Mott Foundation Building. There was also extensive live media coverage from the local TV stations. The implosion went off without a hitch to the cheering of spectators. The winds blew the dust cloud to the northwest. While there was little collateral damage, a gas main serving the Mott Foundation Building was crushed, affecting gas service there, and there were broken windows at the old Flint Journal building. It took about a year for the three-story pile of rubble to be cleared and for damage to surrounding streets to be repaired. Harrison Street finally reopened more than a year later in May 2015. An urban plaza opened on the former site of Genesee Towers a month later.

Action Auto

It Seemed Like a Good Idea in the Late 1970s

A lasting effect created by the 1970s energy shortages was the way we get our gasoline. In a few short years, we went from full-service stations that pumped the gas, checked the oil and fixed your car to making ourselves content with self-service stations that offer "pump your own" gas and sold convenience store items without any service bays. This created an opportunity for three brothers—Richard, Robert and James Sabo—to open an auto parts store in Flint called Action Automotive in 1976. The auto parts store was successful enough for the brothers to open more stores in former Sunoco stations, which, of course, also offered Sunoco gasoline. One of them was the former Action Auto No. 2, which stood on Center Road at I-69 in Burton and began as a converted Sunoco station, still offering Sunoco gas. It expanded to include service bays and even had an outbuilding that served as a training center. It was torn down in 2004 and is now a vacant lot with the former training center still standing. Unlike most Action Auto stores, this one did not reopen as anything else. That site was contaminated and was listed as Environmental Protection Agency Superfund site number MID000674879. No one wants to be saddled with the environmental cleanup cost, which explains why this location was abandoned.

But I'm getting ahead of myself. Starting with the one store in 1976, the company grew to twenty-seven stores in 1984. By 1986, Action Auto was doing $60 million in annual business with its chain of combination auto parts, repair and self-service gas stations with locations throughout central Michigan. The company went public in 1987 when it had fifty-two stores and

A 1984 Action Auto ad in the *Flint Journal*. *Courtesy of the Flint Public Library.*

a long-term debt of $16.4 million. The Action Auto management was very ambitious and even offered franchises. It wanted to be the McDonald's for your car and designed a unique hip roof for not only its one-stop auto shops but also for its gas station canopies. They even made the roof design a registered trademark. The unique design of the roof allows you to figure out which locations were former Action Auto stores. In 1988, it grew to sixty-seven stores and opened a huge distribution warehouse at the corner of Longway and Averill in Flint. But the rapid growth created a staggering $36.2 million long-term debt. At its peak, it was a $100 million operation with seventy-one stores. But the combination of rapid growth and undercapitalization was the company's Achilles' heel, and the company filed for Chapter 11 bankruptcy protection in 1990. Action Auto auctioned off fifty properties, including twelve stores, reducing the number of stores to forty-five.

Most of the Action Auto stores, thirty-two of them, were sold to Total Petroleum in 1991, and most were converted to Total stations. I believe Total sold the locations that were located near existing Total locations. The number of Action Auto properties Total acquired increased to fifty-five stores after a deal was made with the State of Michigan limiting Total's liability for former Action Auto properties that were contaminated sites to $14.2 million. These Total stations were later converted to Speedway stations after Speedway parent Marathon Ashland Petroleum bought Total's retail operations in Michigan. What was left of Action Auto became ServiceMax Tire and Auto Centers of Michigan, owned by an investment firm, which leased the service bays of former Action Auto stores from Total. There were twenty-seven ServiceMax shops that initially offered parts and service, but the model switched to the more profitable mix of tires

and service. But that didn't last very long. Locally, ServiceMax shrank from seven Flint area locations in 1994 to two in 1997 and none in 1998. One former Action Auto in Clio became a Chrysler dealership, and you can still see the distinctive Action Auto look on this dealership. Some former Action Auto locations were acquired by Coopersville, Michigan—based Admiral Petroleum, which converted the service areas of its locations to retail space.

The downfall of Action Auto/ServiceMax led to former executives facing criminal charges. The first to face charges was Donald R. Nance, who was chief financial officer of both Action Auto and ServiceMax. Nance was indicted in 1999 on ten counts of tax evasion, one count of bank fraud for defrauding Providian Financial and Bank One in 1994–95 by submitting false financial statements to the banks on loans totaling $175,000 and one count of making false statements by applying for loans using his position as ServiceMax president and using the money for personal, rather than business, reasons. Federal officials said Nance stole at least $1.3 million from ServiceMax and its employees. He pleaded guilty on June 19, 2000, for filing false tax returns for the 1993 tax year when he claimed no income but made more than $349,000 that year, owing taxes of $114,700. The following January, federal judge Paul Gadola sentenced Nance to seventy months in prison, fined him $100,000 and ordered him to pay $82,000 restitution to the banks he defrauded. Gadola called Nance a "master of deception."

The multiple bankruptcy filings raised the suspicion of federal authorities. In October 1997, a government informant said that he and Action Auto co-founder and chairman Charles Sabo went to a pond behind Sabo's Grand Blanc home, poured diesel fuel on about a dozen boxes containing corporate records and burned them. A former business associate of Sabo, Jeffrey Martineau, told federal officials he believed some of the boxes contained corporate documents Sabo was ordered to surrender to a federal grand jury. On April 12, 2001, Sabo pleaded guilty to several charges, including admitting he took money from his employees' 401k plans to help one of his failing companies. He denied destroying company documents but admitted he did not turn over required business records to the grand jury. The IRS, the FBI and the Department of Labor jointly investigated Sabo's case.

James Sabo was sentenced on November 8, 2001, to thirteen months in federal prison, ordered to pay restitution of more than $78,280 and fined $30,000. He pleaded guilty on one count each of conspiracy to embezzle pension plan assets, concealment of assets and obstruction of justice for

his role as secretary and board chairman of UST Tech. James Sabo's indictment indicated that he committed bank fraud between September 1992 and December 1994 by securing credit lines totaling $2.57 million and borrowing $590,000 using forged signatures and false information.

While some former locations were torn down for redevelopment or are vacant, there are former locations that still serve as gas stations/convenience stores that are mostly Speedway or Admiral locations, and the former location in Vienna Township is still a Chrysler dealership.

The Statues of Flint

In recent years, Flint has become known for its collection of statues. Most of the statues are located in downtown Flint and devoted to the town's automotive heritage.

The earliest statue was unveiled the same year Riverbank Park opened. On the north side of the Flint River east of Harrison Street is a statue of American Revolutionary War hero General Casimir Pulaski, a native of Poland. The statue was dedicated on October 14, 1979, as a gift of the Polish American Bicentennial Committee of Flint in observance of the 200th anniversary of General Pulaski's death after he was mortally wounded in battle.

The next set of statues was erected where Flint's carriage industry, which predated Flint's automotive industry, was based. Located on Water Street on the western side of the Flint River are the restored administration buildings of the Durant-Dort Carriage Company, where it is said that General Motors was born in 1908 and across the street is Durant-Dort carriage factory No. 1. Along the river next to a truss bridge connecting Carriage Town to downtown are the statues of the co-founders of the Durant-Dort Carriage Company: William C. "Billy" Durant and J. Dallas Dort.

Billy Durant's statue, sculpted by Derek Wernher, was unveiled on December 8, 1986. Its companion statue of J. Dallas Dort was also sculpted by Wernher and dedicated on May 20, 1992.

The next set of statues was unveiled over time to note a significant series of events in both Flint and organized labor history. These statues are in

Sitdowners Memorial Park behind UAW Region 1-C headquarters on Atherton and Van Slyke Roads and commemorated the 1936–37 Flint sit-down strike, which led to General Motors recognizing the United Auto Workers union. The first statues are on the main UAW Sitdowners Monument, which features a granite base, a surrounding walkway of bricks and sculptures of different workers and a member of the Women's Emergency Brigade delivering goods to the strikers surrounding an eternal flame. Designed by Jim Arnes Studio, the statues were sculpted by Janice Trimpe and dedicated on Labor Day 2003.

Sitdowners Memorial Park was developed by the UAW to replace a deteriorating monument to the sitdowners that was located downtown at Riverbank Park. That monument was dedicated in 1987 to commemorate the fiftieth anniversary of the sit-down strikes. The three cement seats depicting car seats the sitdowners sat on during the strikes from the original monument were moved to Sitdowners Memorial Park.

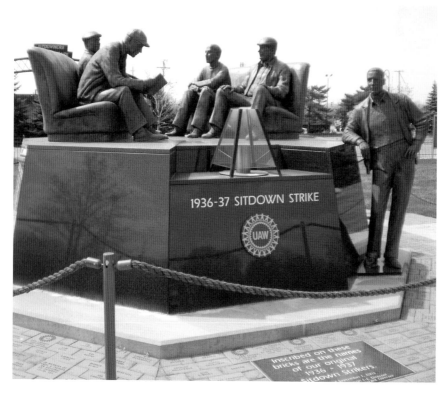

Statues depicting sitdown strikers at Sitdowners Memorial Park. *Gary Flinn.*

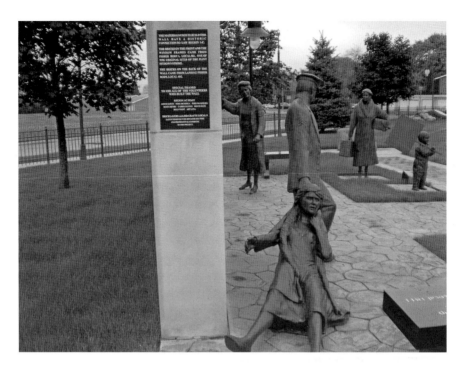

Statues depicting members of the Women's Emergency Brigade at Sitdowners Memorial Park. *Gary Flinn.*

On Labor Day 2009, a separate monument dedicated to members of the Women's Emergency Brigade—wives and daughters of sitdowners who aided the strikers—was added. Two new statues were added to the original Emergency Brigade member's statue that was moved to the new memorial, sculpted by Stan Watts, depicting an Emergency Brigade member being dragged by a police sergeant and another member breaking a window on a brick wall. The brick wall is significant, as it was built using salvaged bricks from the demolished Fisher Body No. 1 plant—one of the original sit-down strike locations—with the rear portion of the wall built using bricks from another Fisher Body plant in Lansing. There is also a statue of a "sitdowner tyke" supporting his father. Adjacent to the original monument, you can still see the bolts where the original Women's Emergency Brigade statue once stood.

On October 2, 2010, a statue of Mahatma Gandhi was dedicated inside a circular "peace garden" at Willson Park on the University of Michigan–Flint campus. Sculpted by Astok Gudigar and shipped from India, the project was spearheaded and funded by Dr. Marigowda Nagaruju, who had a practice in Flint, and his wife.

The most significant set of statues was erected by Back to the Bricks Inc., the organization most responsible for the August Back to the Bricks celebration of Flint's automotive heritage in which classic motor vehicles converge on downtown Flint. It began in 2005 as a one-day car show and evolved into one of the country's premier automotive events. The idea for erecting statues of Flint's significant automotive figures was conceived by sculptor Joseph Rundell, who convinced Back to the Bricks founder Al Hatch that it was a good idea. All the statues are created by Rundell and his wife, Zadra.

The first statue, of Chevrolet co-founder Louis Chevrolet, was dedicated during Back to the Bricks on August 18, 2012, which happened to be this writer's birthday. After the unveiling, this writer noticed a significant typo in the inscription, with this sentence regarding a dispute between Chevrolet and partner Billy Durant: "The two men differed on product—Louis built the large and luxurious Chevrolet Classic Six. But Durant wanted a smaller car to compete with Ford's Model T—so the parted company." Of course, "so the parted company" should be "so they parted company." After the Chevrolet statue's pedestal suffered damaged from the following harsh winter, repairs the following year included correcting the inscription.

Chevrolet's statue was joined the following December 1 by a statue of Buick Motor Company founder David Buick. That statue was made possible by funding from local company Attentive Industries.

The next downtown statue was unveiled during Back to the Bricks on August 17, 2013, a second statue depicted of General Motors founder Billy Durant. While the first statue of Durant showed him wearing a vested suit with an overcoat and derby hat, the second statue showed Durant wearing a full vested suit with a blazer, a thicker overcoat and an ascot cap.

Back to the Bricks for 2014 marked the debut of another automotive pioneer's statue. But this was not a pioneer auto maker; instead, the statue is that of a pioneering automotive retailer whose business celebrated its centennial that year. Otto P. Graff's statue was unveiled on August 16, 2014, by members of the Graff family. The inscription on that statue's pedestal shows an illustration of patriarch Otto, his son Max, grandson Hank and great-grandson Chris. The statue is located across from the Genesee County Courthouse at the corner of Saginaw and Court Streets on the former site of the first Graff car dealership: Otto P. Graff Ford. The Graff family now operates a chain of eleven automotive dealerships in Michigan and Ohio.

The 2015 statue unveiled during Back to the Bricks on August 15 depicted Albert Champion, the Parisian-born bicycle racer who founded two spark plug companies that bear his name. The first company was the Boston-based Albert Champion Company, which he founded with the Stranahan Brothers. While in Boston, he was lured by Billy Durant to establish the Champion Ignition Company in Flint. Legal action by the Stranahan Brothers' Champion Spark Plug Company forced Champion to change the name of his later company to AC Spark Plug after his initials. It became part of GM. The Albert Champion statue shows him holding an actual Champion spark plug.

The 2016 Back to the Bricks statue was unveiled on August 6 in front of the Mott Library entrance on the campus of Mott Community College. It was for the last surviving automotive pioneer, Charles Stewart Mott, on land that was originally part of his Applewood estate where the present Mott Community College main campus now stands. First called Flint Junior College upon its founding in 1923, it was originally located at Flint Central High School then located behind it in the old Oak Grove Campus buildings which formerly served as a sanitarium, before it became Flint Community Junior College when it moved to its present campus in 1955. It was renamed Genesee Community College in 1970 before it was finally renamed Charles Stewart Mott Community College after Mott died in 1973 at age ninety-seven.

Additional statues of local automotive figures are planned by the Back to the Bricks automotive pioneers statue fund. A statue depicting Walter P. Chrysler, who ran Buick in its early years and later founded Chrysler Corporation—also funded by Back to the Bricks—is located inside the terminal at Bishop Airport.

The weekend after Back to the Bricks marks another significant event that draws wide attention: the Crim Festival of Races, which was founded in 1977 by Michigan speaker of the house Bobby Crim as a ten-mile road race to benefit the Special Olympics. Over time, additional activities were added, but the Saturday morning ten-mile race along Flint streets is still the main attraction. On August 21, 2014, during that year's festival of races, a statue of Bobby Crim was unveiled at the corner of Saginaw and Union Streets in front of the Riverfront Residence Hall. The statues both in place and in the planning stages at various Flint locations depict both Flint's automotive legacy as well as the legacies of major figures in the form of General Pulaski and Mahatma Gandhi, major icons to the Flint area's Polish and Indian communities, as well as Bobby Crim, who started the Crim Festival of Races.

The Second Flint Water Scandal

As we left off in chapter 29, a real estate profiteering scandal led the City of Flint to abandon a pipeline project to provide water to Flint from Lake Huron and instead chose to buy water from the City of Detroit. But as the years passed by, rate increases by Detroit had made Flint water unusually expensive. A 2003 power outage affecting the Detroit water system highlighted the need for a reliable water source under local control. For decades, officials have complained of high costs for the water and a price formula that penalizes this area because of its distance from Detroit and its elevation. That led to plans for a rival water pipeline from Lake Huron to commence in 2007 and the formation of the Karegnondi Water Authority (KWA) in 2010.

In the meantime, Flint's financial problems led to the appointment by governor Rick Snyder of an emergency financial manager (EFM). Ed Kurtz, the first EFM, suggested that the KWA was the best option financially to serve Flint's water needs. On March 2013, the Flint City Council endorsed the city joining the KWA, a move approved by state treasurer Andy Dillon.

To aid in the construction of the pipeline, which began in 2013, American Spiral Weld built a pipeline factory to provide pipes for the new water line in 2014 on a portion of the old Buick City factory complex site. While the pipeline was completed in 2016, Genesee County's water plant in Lapeer County's Oregon Township was still under construction, with completion planned in 2017.

But in the meantime, increasing costs for Detroit water coupled with the City of Flint's financial problems led Flint EFM Darnell Earley to order Flint to disconnect from the Detroit water system in April 2014. That was one year after Flint decided to join the KWA, and the Detroit Water and Sewerage Department gave Flint only one-year notice that it was terminating its water contract with Flint. Until Flint connects with the new KWA pipeline, Flint would be getting its water from the Flint River. But organic material in the river water—combined with aging water pipes in some Flint neighborhoods—led to complaints by some Flint residents who were still paying for high-priced discolored water that smelled and tasted bad. Some residents complained that the water was causing rashes and eye irritation.

The excess amount of chlorine in the water, which caused premature corrosion in machinery, led the General Motors Flint Engine Plant to switch back to Detroit water until the KWA pipeline goes on line. That should have been a warning signal to authorities that corrosion of aging lead pipes would lead to excess lead content coming out of Flint faucets. Major upgrades were made to the Flint Water Plant to treat the river water. A short-term fix to satisfy complaints about organic material mixing with chlorine to create undesirable total trihalomethanes (TTHM) is to add a charcoal filtration system to remove organic material. That filtration system may not be needed once the KWA pipeline from Lake Huron is operational.

In September 2015, Dr. Mona Hanna-Attisha of Hurley Medical Center's Hurley Children's Hospital confirmed claims made for several months that Flint's small children had elevated levels of lead in their systems. That led to denials by critics, which took its toll on Hanna-Attisha. But the following month, the Michigan Department of Environmental Quality finally admitted that it used the wrong federal standards in testing Flint water. Hanna-Attisha was vindicated, and the state apologized to her. The river water may have been a factor in an outbreak of Legionnaire's disease in the Flint area. Legionnaire's bacteria can also develop due to stagnation in

The heroine of this story, Dr. Mona Hanna-Attisha. *Gary Flinn.*

A Hydro-Guard automatic flushing and monitoring system installed on a fire hydrant to prevent stagnant water, which can cause development of legionella bacteria. *Gary Flinn.*

underutilized water mains. So selected fire hydrants were fitted with Hydro-Guard automated flushing units to avoid stagnating water lines. In the meantime, until the KWA pipeline is operational, the State of Michigan, the C.S. Mott Foundation and the city shared in the cost of switching back to Detroit water as its water source.

The 2010s version of the Flint water scandal attracted statewide, national and international news attention and caught the eye of celebrities and politicians in the election year 2016, making the scandal a major campaign issue.

Heads began to roll with the mayoral election on November 3, 2015, when Flint mayor Dayne Walling, who flipped the switch on April 25, 2014, changing Flint's water supply from Detroit water to Flint River water, was defeated in his bid for reelection by Dr. Karen Weaver. The following month, Mayor Weaver declared a state of emergency. On December 29, Michigan Department of Environmental Quality (MDEQ) director Dan Wyant resigned, and Michigan governor Rick Snyder apologized to the City of Flint. MDEQ spokesman Brad Wurfel also resigned that day. On January

21, 2016, the Region 5 director of the Environmental Protection Agency in charge of this area, Susan Hedman, resigned. Hedman had covered up warnings by EPA water expert Miguel Del Toral that the Flint water plant did not provide corrosion control after switching to river water. On February 5, former MDEQ water and municipal assistance head Liane Shekter Smith, who was reassigned and suspended the previous October, was fired.

Hedman's successor, acting EPA Region 5 director Robert Kaplan, took over on February 1 and took the water crisis head-on in helping the city recover, saying the EPA is in it for the long haul.

City of Flint residents were able to receive free faucet filters, bottled water and water testing kits from several locations around the city, including Flint fire stations and Genesee County Community Action Resource Department locations. For the benefit of residents unable to pick up the items themselves, the National Guard and work release inmates were going door to door to make sure residents had access to faucet filters, replacement cartridges, test kits and bottled water. Various individuals and organizations from near and far have donated bottled water and provided funds along with Mayor

A crew replaces the lead service line for a home with a copper service line. *Gary Flinn.*

Weaver's $55 million Fast Start to help pay for replacement of lead water lines leading to homes with young children and the worst lead readings. Later, the water pickup locations were relocated from the fire stations to locations in each of the city's nine wards, which also offered faucet filters, replacement cartridges and water test kits. The city would not receive water from the KWA until at least October 2017 if it bought water from Genesee County as it was determined at this writing that it would cost $108 million to upgrade the Flint water plant and would not be ready to treat KWA water until 2019. The MDEQ is providing training for Flint Water Plant personnel at the treatment plant.

On October 2016, the EPA inspector general determined that the EPA Region 5 office should have issued its emergency order as soon as June 2015, but it waited seven months before that order was issued. The Region 5 office's reluctance to take action at that time was due to the culture that developed in that office after regional administrator Mary Gade was fired in 2008 for raising the ire of politicians due to her actions forcing major employer Dow Chemical to speed up removal of toxic dioxin waste from Saginaw-area rivers.

The reluctance of some people to wash their hands with Flint water is considered a factor in an outbreak of Shigellosis. This led to a public service announcement campaign to ask Flint residents to wash their hands. Using hand sanitizer is not enough.

This writer lives in the city of Flint and has had the water tested several times. Upon availability, I obtained Brita faucet filters first for the kitchen faucet and then for the bathroom faucet. Of course, I began to use the free bottled water, but I was choosy regarding brands, with Michigan-based Absopure being my preference and rejecting water from Nestlé, which consumes Lake Michigan aquifer water from wells in Mecosta County for little money, if any. The first test was made in October 2015 while still using river water. The result with the bathroom faucet was no copper detected, and the lead reading was 6 parts per billion (ppb) with the EPA Action Level being 15. The second test back on Detroit water took place on January 2016 using the kitchen faucet with the result showing 160 ppb of copper in the water, and the lead reading was 26 ppb. So the problems with my pipes were much worse. The plumbing inside the house is copper with mostly lead solder joints, and the intake pipe from the basement floor to the main shut-off valve is also copper. Revisiting the bathroom faucet, the April 2016 result was 60 ppb of copper and 7 ppb of lead. After the May 2016 flushing campaign, bathroom faucet water

MICHIGAN DEPARTMENT OF ENVIRONMENTAL QUALITY
DRINKING WATER LABORATORY

P.O. Box 30270
Lansing, MI 48909
TEL: (517) 335-8184

Sample Number
LG49210

Official Laboratory Report

Report To: GARY FLINN
FLINT, MI
48503

System Name/Owner: GARY FLINN
Collection Address:
Collected By: GARY FLINN
County: Genesee
Sample Point: KITCHEN

Date Collected: 05/27/2016
Date Received: 06/02/2016

Metal	Result In Parts Per Billion (ppb)
Copper	5390
Lead	977

What the Results Mean: The result tells you how much lead and copper is in the water
• If the result for Copper is "Not Detected", that means the amount of copper in the water was less than 50 ppb.
• If the result for Lead is "Not Detected", that means the amount of lead in the water was less than 1 ppb.

No matter what your lead result is, you should continue to use an NSF certified filter until the Public Health Emergency Declaration has been lifted.
• Filtered or bottled water should be used for all drinking, cooking and washing of fruits and vegetables.
• Filtered or bottled water should also be used for children brushing their teeth and for watering pets.

Important: For children younger than 12 months of age, use *only* bottled water to make formula, for drinking water, and to make any other food product.

If your Lead result is greater than 150 ppb OR your Copper result is greater than 1,300 ppb:
• Contact the Genesee County Health Department at (810) 257-3603 (if you have not already been contacted)
• Use only bottled water for drinking, cooking and washing fruits and vegetables.

Please note, other faucets in your home may have higher levels of lead, even if this sample is low. Do not drink or cook with water from other faucets unless they have been tested and have a filter.

Everyone can use unfiltered tap water for washing your dishes and clothes, and for cleaning your house. You can also shower and give kids baths in unfiltered tap water, but keep kids from getting the bath water in their mouths. No amount of Lead is safe for kids.

For more information go to: www.mi.gov/flintwater or call 800-662-9278

Work Order 600000472_45 Report Created on: 6/7/2016 12:44:18PM Page 1 of 1

The reason this writer's kitchen received a free replacement faucet and under the sink filter. *Gary Flinn.*

quality improved to no copper detected and 4 ppb of lead. So the bathroom faucet is fine.

But the kitchen faucet is another story. When I was flushing the kitchen faucet during the May 2016 flushing campaign, I followed instructions and used the bypass knob on the faucet filter. The test afterward that May was alarming. The copper result was 5390 ppb of copper and 977 ppb of lead. This led to a visit from a water inspection crew to look at my plumbing. I then began to flush the lines using the garden hose spigot on the other side of the kitchen wall. While doing that, I continued to test using the kitchen faucet. But after the last test, I disposed of the old kitchen faucet filter, which I thought had become contaminated due to the flushing. From that point on, I physically removed the faucet filter before testing. The June test was an improvement, with 530 ppb of copper and 81 ppb of lead. But I was still concentrating on flushing the outside spigot instead of the kitchen faucet. So the July test, which showed a significant improvement on the copper side with just 70 ppb of copper, was not all good news: the lead reading had jumped up to 160 ppb of lead, which led the Michigan Department of Environmental Quality to contact me. What they suggested was to concentrate on flushing the kitchen faucet (with the faucet filter removed beforehand) and not the outdoor spigot. They say older faucets and shut-off values do contain lead, so I should allow the phosphates to coat the kitchen faucets and the fittings under the kitchen sink. The bathroom faucet is much newer, and the MDEQ official told me that newer faucets, like my bathroom faucet, are lead free. On the morning of August 18, when I turned sixty-two, I received a phone call from the State of Michigan telling me that due to the high lead readings from the kitchen faucet I would be receiving a free new kitchen faucet and an under the sink filter. The following day, I took the final water sample from the old faucet. The test result was 90 ppb of copper and 5 ppb of lead.

When it was time to get my routine blood test, I asked that my blood be tested for lead as well. The test result showed my blood was fine regarding lead content.

On August 24, a plumber and plumber's helper from the plumbers' union United Association Local 370 arrived to replace the old kitchen faucet and install a new to the market 3M under sink filter—which states on the package that it removes 99 percent of lead—along with a spare filter cartridge. The filter cartridge lasts six months, and I would be getting a free replacement cartridge at six-month intervals. The plumber assured me that the shut-off valves are of a newer design and would not have lead in them. After they finished the job and left, a four-person crew from the United Way of Genesee County and 3M arrived to check on the work and interview me regarding my experience going through the Flint water crisis. The intention of the video interview was to convince 3M to contribute additional under sink filters to help additional Flint residents with problem faucets. The following day, I did a test sample with the new kitchen faucet, and the day after, I did a comparison test sample with the bathroom faucet. The test results for the kitchen faucet was that copper and lead were not detected. For the bathroom faucet, copper was not detected, and the lead reading was 4 ppb. As part of the agreement with 3M, the United Way and UA Local 370, to receive the new faucet and under sink filter, up to six water samples per month are required. This writer developed a routine of getting new water samples after receiving results of the previous water samples. The water test kits are obtained from official city water pick-up locations in each ward, and the filled samples are dropped off at the same locations. The flushing

The old faucet causing high lead readings is replaced. *Gary Flinn.*

routine led to positive results, with the following four water test samples of the bathroom faucet having no copper or lead detected, same with the new kitchen faucet. Starting with the third bathroom faucet test in early October 2016, the strainer was reattached prior to testing. Also that October, the MDEQ started distributing new test kits with two bottles with instructions to fill the smaller bottle first. The reason is to determine lead and copper content coming from the faucet with the first bottle, with the second bottle used to test the rest of the plumbing.

With the positive results, I let the supply of bottled water run out, but I'm still using the bathroom's faucet filter for good reason. The first bathroom faucet test results using the two-bottle test kit showed no copper detected, but for lead, the 250-milliliter sample showed two ppb of lead and the 750-milliliter sample showed no lead detected. The calculated 1-liter result was no lead detected. When I used the two-bottle test kit on my kitchen faucet, the 250-milliliter sample also showed two ppb of lead, so I let the kitchen faucet run for a few seconds before using the water for drinking or food preparation.

The United Way of Genesee County also wanted a separate water sample with a special water kit they provide with a different form to fill out for those who received 3M under sink filters, and the organization picks up the filled water test kit. That was only for my kitchen faucet. The first three sample test results again showed no copper and no lead detected from the kitchen faucet using their single one-liter bottle test kit.

After wearing out two Brita faucet filters in the bathroom, I switched to a Pur faucet filter, which is more durable. The most recent test result at this writing for the bathroom is 1 ppb of lead in the small bottle and no lead in the large bottle. The most recent kitchen faucet test result showed no lead at all.

So if it weren't for the scandal in the 1960s, Flint would have had its own source of Lake Huron drinking water a half century before, and we would not have the water problems Flint residents had to endure from 2014 onward.

Part of the chronology utilized a timeline compiled by the staff of Bridge *magazine titled "Disaster Day by Day: a Detailed Flint Crisis Timeline" from http://bridgemi. com/2016/02/flint-water-disaster-timeline.*

Bibliography

This book makes extensive use of chronologies from the following sources at the Flint Public Library:

Flint City directories published in 1872–73 by Angevine & McCormick; 1874–76 by N.H. Burch & Company; 1881–82 by H.G. Osborne; 1894–1903 by Glen V. Mills and 1885; 1892–93; 1905–91 by R.L Polk & Company.

Microfilm reels

Flint Daily News, 1886–1905
Flint Journal (Flint Daily Journal and *Flint Sunday Journal)*, 1903–present
Flint News-Advertiser, 1943–57
Suburban News, 1973–2001
Wolverine Citizen, 1850–1911

Books and Periodicals

Bader, Robert S., ed. *Groucho Marx and Other Short Stories and Tall Tales.* Milwaukee, WI: Applause Theatre & Cinema Books, 2011.
Cavanaugh, Peter C. *Local DJ: A Rock 'n' Roll History.* Bloomington, IN: Xlibris, 2002.

Centennial and Welcome Home Committee Subcommittee on Historic Sites. *Summary of the Early History of Flint, Michigan*. Flint, MI: Flint Printing Company, 1919.

Clever, Anita K. "Fifty Years an Inventor." *Popular Mechanics* 102, no. 5 (November 1954): 108–10.

Committee of Sponsors for the Flint College and Cultural Development and the Flint Board of Education. *Flint's Community College and Cultural Center*. Flint, MI: n.p, 1958. a pamphlet

Cutler, Charles L. *Tracks That Speak: The Legacy of Native American Words in North American Culture*. Boston: Houghton Mifflin Company, 2002.

Dannett, Sylvia G.L. *She Rode with the Generals*. New York: Thomas Nelson & Sons, 1960.

Edmonds, Sarah. *Nurse and Spy in the Union Army*. Hartford, CT: W.S. Williams & Company, 1865.

Fine, Sidney. *The General Motors Strike of 1936–1937*. Ann Arbor: University of Michigan Press, 1969.

Flint City Planning Board, *The City Plan of Flint, Michigan, Including the Reports of John Nolen, City Planner, and Bion J. Arnold, Transportation Engineer, As Approved by the City Planning Board and Accepted by the Common Council*. Flint, MI: Flint Publishing Company, 1920.

Genesee County Historical Society. *Picture Palaces & Movie Houses*. Flint, MI: Advertisers Press Inc., 1999.

Gustin, Lawrence R. *Billy Durant: Creator of General Motors*. Grand Rapids, MI: William B. Eerdmans Publishing, 1973.

———. *Picture History of Flint*. Grand Rapids, MI: William B. Eerdmans Publishing Company, 1976.

History of Genesee County Michigan.. Philadelphia: Everts & Abbott, 1879.

Lovish, Simon. *Monkey Business: The Lives and Legends of the Marx Brothers*. New York: Thomas Dunne Books, 1999.

Mabbitt, Bob with Gary Flinn and Adam Gerics. "This Land Is My Land." The *Uncommon Sense* 4, no. 6 (June 2006): 10–11.

Metcalf & Eddy Engineers. *Report to City Manager, City of Flint, Michigan upon Adequacy of Existing Water Supply, December 13, 1955*. Boston: Metcalf & Eddy, 1955.

Moser, Whet. "What Did the EPA Do Wrong in Flint?." *Chicago Magazine*. January 25, 2016. http://www.chicagomag.com/city-life/January-2016/ EPA-Flint-water-lead.

National Audubon Society, *Survey Report and Outdoor Education Plan, For-Mar Nature Preserve and Arboretum*. New York: National Audubon Society, 1968.

Nemett, Adam. *Huntington at 150: A Banking Genealogy*. Columbus, OH: Huntington Bancshares Inc., 2016.

Sebree, Mac, and Paul Ward. *Transit's Stepchild: Trolley Coach*. Cerritos, CA: Interurbans, 1973.

Smith, William V. ed. *An Account of Flint and Genesee County from Their Organization*. Dayton, OH: National Historical Association, 1924.

Stevenson, Franklin L. *A Pictorial Souvenir of Flint, Michigan "The Motor City."* Flint, MI: The Curtis Printing Company, 1928.

Tales of Early Flint. Flint, MI: Flint Board of Education, 1951.

Thomas, Gordon, and Max Morgan-Witts. *The Day the Bubble Burst: A Social History of the Wall Street Crash of 1929*. Garden City, NY: Doubleday, 1979.

Tichenor, Harold. *The Blanket—An Illustrated History of the Hudson's Bay Point Blanket*. Toronto: Quantum Book Group Inc., 2002.

Wood, Edwin O. *History of Genesee County Michigan: Her People, Industries and Institutions*. Indianapolis, IN: Federal Publishing Company, 1916.

About the Author

G ary Flinn is a product of the Flint Community Schools and a graduate of Mott Community College and Michigan State University who has lived in the Flint area most of his life. His earliest writings were for Flint Central High School publications the *Tribal Times* and the *Arrow Head*. Besides *Broadside*, he also contributed articles for the *Uncommon Sense, Your Magazine*, the *Flint Journal* and *Downtown Flint Revival* magazine. He presently lives on Flint's west side.

The author wearing his capote described in chapter 2 at the Sloan Museum. *Photo by Ivonne Raniszewski.*